FRIDA KAHLO
Song of Herself

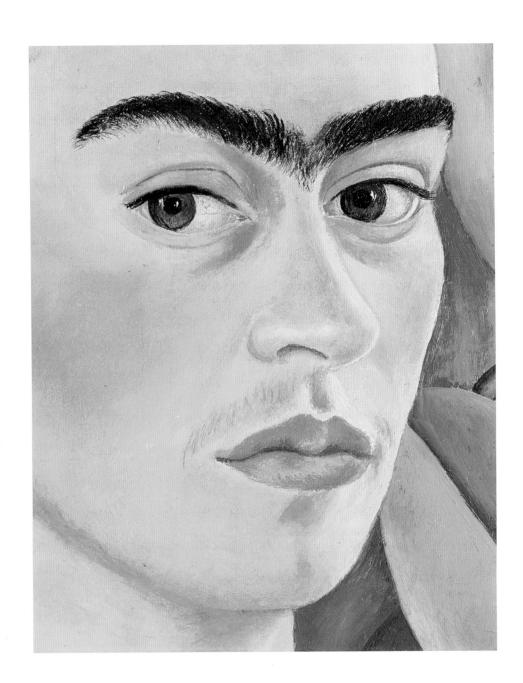

FRIDA KAHLO
Song of Herself

SALOMON GRIMBERG

MERRELL

LONDON · NEW YORK

In memory of

Regina Nankin Elfenbein

and

Olga Campos

Where is, heart of mine, the place of my life?

Where is my true home?

Where is my precise abode?

Here on earth I suffer!

—PRE-HISPANIC SONG

CONTENTS

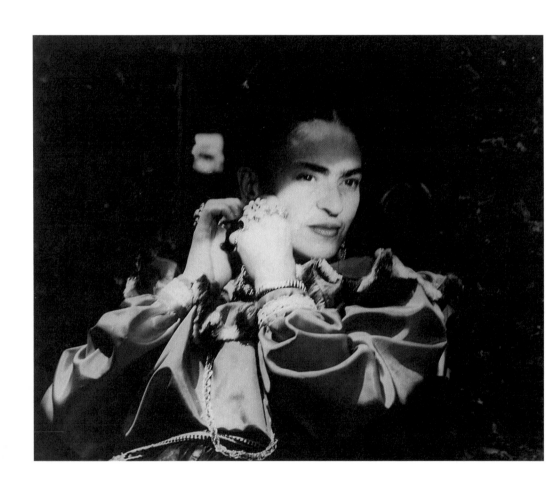

FOREWORD

What a delight to learn something new about Frida Kahlo! So much has been written, the same old facts turned this way and that to give new interpretations. The documents gathered by Salomon Grimberg in *Frida Kahlo: Song of Herself* are a breath of fresh air. They are authentic, insightful, and down-to-earth. From them, we come close to knowing what it would be like to be a friend of Kahlo's—how she dressed, how she entertained, what her pets meant to her, how she spent her days.

In 1947, when she was a university student studying to become a psychologist, Olga Campos met Kahlo and the two became close friends. As part of her research for a book about the creative process, Campos interviewed Kahlo extensively between 1949 and 1950. The notes she took include fourteen pages of Kahlo's ruminations about her childhood. We hear Kahlo's true voice in every sentence. Kahlo also spoke briefly about her approaches to such things as friendship, politics, children, animals, love, sex, death, and her own painting.

Starting in July 1949, shortly before Kahlo attempted suicide, and continuing during the artist's year-long hospitalization, Campos also administered to Kahlo four psychological tests, including a Rorschach. The psychologist James Bridger Harris has assessed the results of these tests, concluding that Kahlo suffered from depression, narcissism, and chronic pain syndrome. She had, he notes, difficulty "maintaining a cohesive sense of self." In Campos's notes and in Harris's interpretations, Kahlo emerges as a person who defied convention, felt she was defective and ugly, feared abandonment, and needed other people's affirmation, especially that of her husband, Diego Rivera. Yet, in spite of having twice considered suicide, she had a powerful will to live.

Olga Campos's memoir of Kahlo, written in 1991, offers an intimate view of the artist and her life in Coyoacán during her last seven years. Campos provides new understanding of Kahlo's relationships, with Rivera, with her sister Cristina, and with the film star María Félix. The image that emerges is of a life that was both lonely and festive. In his essay on Kahlo, Grimberg speaks of her sense of loss and emptiness, her constant self-invention, and her need to hold the attention of others. In her effort to be lovable, he says, Kahlo had to sacrifice "her true self to a mask."

—HAYDEN HERRERA

Frida Kahlo, 1952

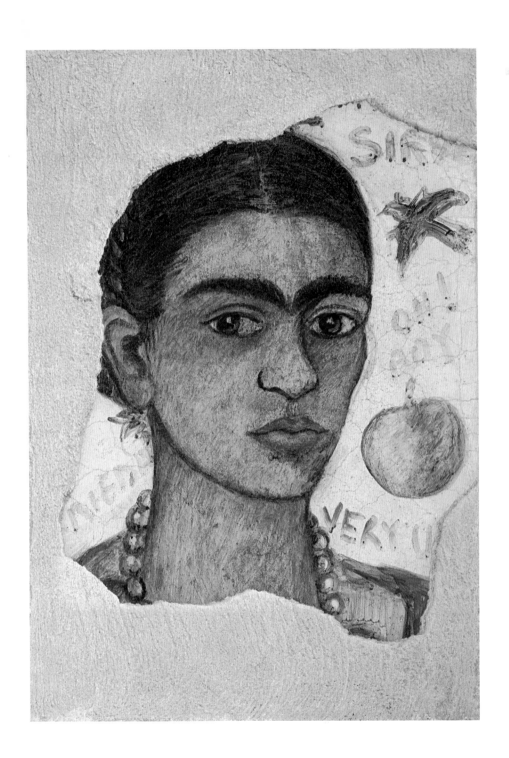

INTRODUCTION

During her short life Frida Kahlo (1907–1954) led an extraordinary existence, one reserved for only a very few. Just as her reputation cut across the definitions of Mexican and Surrealist, of artist, feminist, and cult figure, Kahlo's life crossed paths with some of the great personalities of her time. André Breton, Marcel Duchamp, Joan Miró, Isamu Noguchi, Georgia O'Keeffe, Pablo Picasso, Nelson A. Rockefeller, Yves Tanguy, and Leon Trotsky are just a few of the people who were impressed by her; their effect on Kahlo may be only surmised. Despite what seems to be an endless stream of information about her life and work, Kahlo remains an enigma. In fact, her ambiguity underlies her status as a cult figure: she is a heroine in whom every admirer finds the palliative to his or her own needs. As if looking through a prism, each of us sees a different perspective that appears to be "the one." Some are drawn by Kahlo's *joie de vivre*, some by her relentlessness, others by her sad fragility, some even by her morbidity and manipulativeness. Each can identify with some shared experiences. But what is the basic truth about Kahlo? Why did she speak of herself as "the great concealer"?

In searching for Kahlo's essence, where can one look to gain a finer grasp of what this fascinating woman was about? In 1983, Alejandro Gómez Arias, her childhood sweetheart, wrote in his memoir of her that she was "so contradictory, [so] multiple, that the personality of this woman can be said [to have been made up of] many Fridas."[1] Perhaps Gómez Arias is offering a window through which we may see that Kahlo projected a multifaceted personality: she was a woman with an ever-shifting self, always different, yet always the same. She reshaped herself over and over again in an attempt to establish an internal sense of wholeness. With each transformation she believed she would attain an image that would hold the attention of the people she most wanted to please at that moment, those who provided her with her sense of security and being. And that is how she sustained her sense of self.

Self-Portrait "Very Ugly," 1933

Can we actually deny or avoid our genuine self and adopt an invented one? The answer is yes, if we believe it is the only way to survive. This phenomenon is most readily observed in children, as their sense of security depends on experiencing acknowledgment. Children read—or misread—cues that tell them if the way they are is, or is not, the way to gain acknowledgment from their caregiver. This acknowledgment is vital if the child is to survive psychologically. If acknowledgment is unavailable, the child may shift to an alternate pathway in search of the craved experience. Whether or not this shift is conscious, it may cause the child to move away from the path of genuine self. The child's growth and development can thus be stifled. He or she may enter an equivocal situation, the consequences of which may ultimately lead to annihilation. Along the way, the child may latch on to the belief that this new path is the safe one, the one that will bring harmony. In the process of attempting to please, some children may become aware that they have slipped into a rut, and they may attempt, but not be able, to return to the original path, which is freedom. Others, less aware, may merely sense that something is amiss in their lives, that they are living a miscast existence, and remain confused about where the feeling comes from or what it means. Who can tell which one of us suffers more? No one can ever know the sorrow of others.

Kahlo wrote about this developmental arrest in her diary: "Life passes and offers paths that are not walked in vain. But no one can stop 'freely' to play on the road, because it delays or transforms the general atomic travel. From this comes discontent, from this the hopelessness and the sadness."[2]

Gómez Arias had significant experience that Kahlo's neediness was different from the feelings that one sweetheart has for another. She craved an external, caregiving, organizing force to keep her focused, clear, away from the chaos that otherwise overwhelmed her. Kahlo's letters often literally beg in a childlike way for acknowledgment: "Do not forget me," she signs off repeatedly. Like her self-portraits, her letters were created to keep her ever present in the mind of the recipient. In her earliest documented self-portrait, a drawing done for a grade-school friend, she wrote above her head: "Here I am sending you my portrait so you will remember me" (page 73). Likewise, *Self-Portrait with the Portrait of Dr. Farill* (1951; private collection), Kahlo's

last autographed self-portrait—painted as a gift for her physician in the manner of a votive painting, with a heart on the palette as if to say she painted it with her heart—is still an attempt to establish her presence in the mind of the person for whom it was made.

It is not surprising that Gómez Arias interpreted Kahlo's interest in the artist Diego Rivera (1886–1957), whom she married twice, as that of a helpless child for an omniscient parent: "Rivera opened doors for Frida that she would not have opened alone."[3] Rivera's influence on Kahlo went beyond the gigantic talent and personality he embodied, beyond even his influence as a friend, lover, or husband: Kahlo looked to Rivera for her very sense of being and identity. In the self-portrait *Diego and I* (1949; private collection), Kahlo is crying, and the image of Rivera, who had just requested a divorce to marry the Mexican actress María Félix, is suspended between her brows. On his forehead is an all-seeing eye. Kahlo believed that, just as Rivera derived his awareness from his third eye's capacity to see through appearances, she derived her awareness from his influence on her. From the time that Kahlo met Rivera, her personality was transformed as she committed to the relationship that would culminate in marriage: Kahlo began to behave as Rivera liked her to behave, to dress as he liked her to dress, to paint as he liked her to paint. In a sense, she paralleled Pygmalion's greatest work of art, the one with whom he fell in love. However, Kahlo's transformation was tragic because she allowed Rivera to shape her as he wished. Thoughtlessly, he encouraged in her attitudes and behaviors that would eventually be costly for both. In her self-portrait of 1930, the first she created after her marriage, Kahlo wears a new expression that does not appear in the earlier works: she appears haunted, self-absorbed. She painted herself this way until the end of her life.

Despite countless monographs and innumerable articles printed since the publication in 1983 of the key work on Kahlo, Hayden Herrera's *Frida: A Biography of Frida Kahlo* (Harper & Row), the world still clamors for information on the artist. What exactly do we hunger for? Is it that one reading of Kahlo that would end the discomfort we experience as we face her ambiguous, multifaceted persona?

In 1989, I met Olga Campos (1923–1997) through my previous research on Kahlo. Campos had befriended the Riveras in 1947, seven years before Kahlo's death, and a strong bond had developed between the two women. Kahlo even joked about adopting

Campos, who was young enough to be her daughter. At the time, Campos was enrolled in the prestigious Universidad Nacional Autónoma de México in Mexico City, working toward her degree in psychology. She was interested primarily in the creative process, and was gathering material for a book that would explore the relationship between emotion, color, and line. Each artist Campos interviewed, including, during 1949 and 1950, Kahlo, provided a personal, artistic, and medical history; underwent psychological testing; answered a battery of questions about love, sex, friendship, death, productivity, social awareness, the relationship between self and others, and other subjects; and created non-objective drawings depicting various emotions: love, hate, anger, mirth, jealousy, panic, joy, sorrow, fear, disquiet, anguish, rage. Campos's objective was to detail personal and universal themes in an unfiltered view of the artist's psyche. The book was never completed, and the raw information was stored. (Rats had begun to gnaw at it when it was rescued for this book.) As I read the material, a fresh portrait of Kahlo emerged, and I imagined how the psychological assessment, with an introduction and interpretation, would give the public an unprecedented, direct line to the dynamic forces that shaped this complex woman. James Bridger Harris has kindly written, especially for this book, an interpretation of the material that further illuminates Campos's original notes. Also included is a medical history of Kahlo gathered in 1946 by the obstetrician-gynecologist Henriette Begun, which documents the many physical afflictions that Kahlo endured.

Kahlo's bedside reading was Walt Whitman's "Song of Myself" (1855), a worn copy of which she gave to her lover Josep Bartolí. The cadence in Kahlo's diary often mirrors Whitman's writing, as well as some of his attitudes and personal concerns, and it seemed fitting that the title of this book should reflect this identification. Another poet, Carlos Pellicer, who was Kahlo's dear friend, chosen by Diego Rivera to organize the Museo Frida Kahlo, recalled how Frida hid the sonnets he wrote for her under her pillow for certain visitors to read. Unlike most of those around Kahlo, Pellicer knew the significance of her terrible loneliness, and he believed that her true self would eventually come to light. About their shared loneliness he wrote, "I am nothing. You, everything. With our life full of loneliness, I am the sand and you, the suffered horizontal line."[4] He read the complete poem aloud just before Kahlo's cremation.

Hayden Herrera's biography laid the groundwork for Kahlo—the painter and the person—to become arguably the best-known and most popular woman artist of all time. *Song of Herself* achieves something different. Olga Campos left a "memory" of Kahlo as "someone you could touch." Offered here are facets of Frida Kahlo's personality, captured by Campos, where she speaks for herself, as in an autobiography. What emerges is closer to the person and less to the personage. Readers can almost reach out and touch Kahlo and feel her do the same back as she relates who and what she is, why she thought, behaved, and lived as she did, and what her multifaceted life was about.

—SALOMON GRIMBERG

NOTES

1. Alejandro Gómez Arias, "Un testimonio sobre Frida Kahlo," in *Frida Kahlo, Tina Modotti*, exhib. cat. (Mexico City, Museo Nacional de Arte, June–August 1983), p. 79. Author's translation.

2. Frida Kahlo, *The Diary of Frida Kahlo: An Intimate Self-Portrait*, introduction by Carlos Fuentes, essay and commentaries by Sarah M. Lowe (New York: Harry N. Abrams, 1995), p. 87.

3. Alejandro Gómez Arias, interview with the author, July 1989.

4. Pellicer's recollections were recorded in an interview with Karen and David Crommie for their documentary *The Life and Death of Frida Kahlo* (1966). Pellicer's poem is reproduced in Martha Zamora, *Frida: el pincel de la angustia* (La Herradura: Publicaciones Martha Zamora 1987), p. 221. Author's translation.

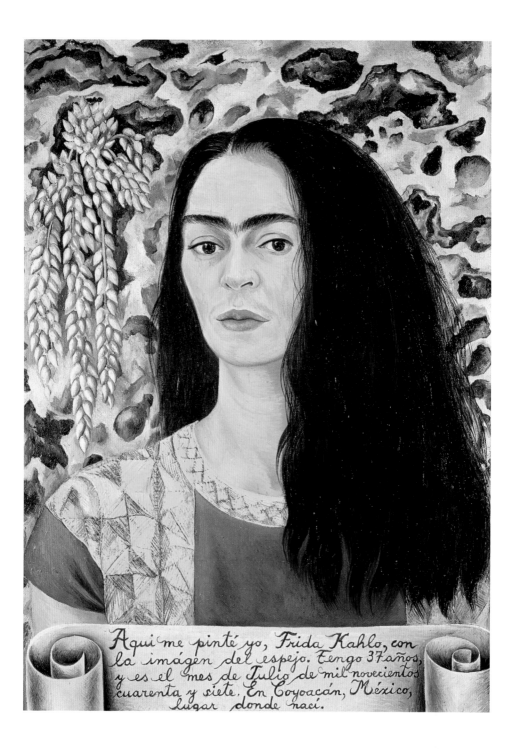

Aqui me pinté yo, Frida Kahlo, con la imágen del espejo. Tengo 37 años, y es el mes de Julio de mil novecientos cuarenta y siete. En Coyoacán, México, lugar donde nací.

"WITH THE IMAGE FROM THE MIRROR"

SALOMON GRIMBERG

In 1947, Frida Kahlo created *Self-Portrait with Loose Hair* (opposite). She portrayed herself against a wall of volcanic rock, to which a donkey's tail plant (*Sedum morganianum*) is attached. Kahlo looks haggard; her gaze is inward. Her hair, parted in the middle, hangs loose over her Tehuana blouse (the traditional dress of Tehuantepec in Oaxaca state), nearly touching the unfurled scroll at the base of the painting, which reads: *I, Frida Kahlo, painted myself here with the image from the mirror. I am 37 years old, and it is the month of July of nineteen hundred and forty-seven. In Coyoacán, Mexico, place where I was born.* An analysis of the self-portrait within the context of Kahlo's biography reveals a rich symbolism that suggests how she perceived herself, how she sought to be perceived by others, and how she perceived her life. Kahlo shaped her confessional *Self-Portrait with Loose Hair* to be misleading about who she was, paradoxically revealing a truth about who she wanted to be. This conflict charges the painting with its power and mystery.

To appreciate *Self-Portrait with Loose Hair*, it is necessary to understand Kahlo's life.[1] Magdalena Carmen Frida Kahlo y Calderón, born on July 6, 1907, in the town of Coyoacán on the outskirts of Mexico City, was the fourth of five children born to Guillermo Kahlo and Matilde Calderón y González.[2] Conceived shortly after the death of her parents' only son, Frida came into the world preceded by a dark cloud. It must have been an emotionally trying pregnancy for Matilde. As often happens in these situations, the grieving mother becomes pregnant wishing somehow to replace the lost child. The wish does not come true: the newborn, not being the lost child, becomes the object of disappointment and unresolved grief.[3] It is not surprising that Matilde Calderón withdrew into depression following Frida's birth and left the care of her newborn to a nanny. By the time she discovered that the nanny was drinking alcohol

Self-Portrait with Loose Hair, 1947

while breastfeeding, the self-absorbed Matilde was pregnant with Cristina, Frida's younger sister by eleven months.

Two of Kahlo's paintings, *My Birth* (1932; private collection) and *My Nurse and I* (page 98), address these issues. Having been entertaining the idea of doing a painting about her birth, Kahlo was spurred into action by the death of her mother. She and Rivera were living in Detroit when they were notified of Matilde's illness.[4] Kahlo arrived in Coyoacán in time to see Matilde alive but would not visit her or view her body afterward. *My Birth* takes place in the room in which Frida was born. Matilde is on her back with her knees spread and her upper torso wrapped in a shroud; she is dead while giving birth. Except for Frida's head, her body remains inside the birth canal. It is not clear whether Frida is dead or alive. The room is abandoned. Above Matilde's head a weeping image of the Virgin of Sorrows, pierced by daggers and bleeding, appears to be observing the scene through a window over the bed. In this painting, about which Kahlo said later, "This is how I imagined I was born,"[5] she implies that her coming into the world was a kind of death to her mother, and alludes to her inadequate attachment to Matilde. During the later part of her life, Kahlo searched for explanations in ancient texts for causes of her innate misfortune. A line from the ancient Egyptian *Book of the Dead*, "I am the great god Nu, who gave birth unto himself," resonated with her.[6] She transcribed it in her diary as "The one who gave birth to herself."[7]

My Nurse and I, which Kahlo considered a companion to *My Birth*, was created five years later, suggesting that the past continued to be active in her. The image of *My Nurse and I* looms brutally direct, and the spectator cannot but react in horror at the sight: Kahlo, with the body of an infant and the head of a woman, lies lifeless in the arms of the nanny, whose face is covered with a pre-Hispanic Teotihuacán mask.[8] The painting is a reversal of the traditional Madonna and Child; it portrays not attachment but loss. There is no mutuality, no affectionate cuddling, holding, touching, or eye contact. Frida does not respond to the nanny's engorged left breast, which, transparent, reveals swollen milk ducts. Her lips do not touch the nipple from which drops of milk spill into her mouth. From the sky falls "milk from the Virgin," Kahlo explained.[9] As in *My Birth*, it is not clear whether Kahlo is dead or alive. Created as

votive paintings, both works include unfurled scrolls, which traditionally contain the narrative of the miracle requested from the Virgin. The scrolls are empty, however, suggesting that there was no hope, even for a miracle.

Kahlo's infancy, shaped by faulty bonding, laid the groundwork for the unstable structure of her future life. She grew up believing that she was not quite right the way she was, that to be more interesting, more desirable, she needed to become another person. Others' disinterest in her would tilt her vulnerable sense of balance, inducing, in terms of her internal reality, a sense that she could not survive.

Kahlo used up much of her vital breath attempting to reaffirm her identity in the eyes of others. The performance was mesmerizing, but it entailed the sacrifice of her true self to a mask. Beneath the regal demeanor of the personage she presented, she was a professional seductress. *Self-Portrait Drawing* (page 28) reveals in detail how she studied her image in the mirror in preparation for a self-portrait. It is an uncanny image of Kahlo observing Kahlo observing herself, self-consciously natural, wanting the viewer to perceive and remember her precisely how she wanted to be remembered. Five arms grow out of her right shoulder, one hand fixing her hair, two steadying her face, one holding on to a sketchbook, and one falling to the side of her dress.[10] The Frida Kahlo ultimately portrayed is twice removed, an image of her image. This is not the real Frida Kahlo but an interpretation of her reflection, of the image she used to inform her self. And us.

Of the four Kahlo sisters, Frida was the most dependent on her mother, although as an adult she vehemently denied it.[11] Mati (Matilde), the eldest, was Matilde's favorite. When Frida was about seven, she helped Mati elope and did not say a word, even to her mother, whom she watched grieving for her missing daughter. Since children tend to react impulsively, without giving a second thought to their behavior, Frida could not have fathomed her mother's sorrow. What mattered was her need to be gratified and, with Mati gone, in her child's mind she must have believed she had a better chance of becoming the favorite. About the same time, Frida suffered poliomyelitis, and the resulting shorter, thinner leg confirmed her sense of being defective. Polio sequelae drew jokes from other children but also extra attention from her parents, who went

out of their way to make her feel special.[12] She discovered that people would do more for the ill than for the well, and she began to link illness with caring.

Building on what she had learned while convalescing from polio about the value of helplessness, Kahlo took on the identity of a professional patient when she was involved in a bus accident on September 17, 1925. During three months at the Red Cross Hospital in Mexico City, while recovering from multiple fractures to her back, pelvis, and right leg and arm, plus injuries to soft tissues, she wrote: "I am beginning to grow accustomed to suffering."[13] Thereafter she reacted to conflict with physical symptoms, winning attention she might not otherwise have gained. In being ill, Kahlo could somehow ameliorate, if not meet, the needs engendered by an early sense of deprivation. This approach could only be a palliative, however, and, just as a painkiller soothes but does not heal, the rewards of illness only masked the problem. Kahlo's pervasive sense of loss remained close to the surface, experienced as abandonment, neglect, or rejection.

By July 1932, when Kahlo began to paint a visual diary of her life, it was a given that loss would mint the iconography by which she would become famous. It began with the pivotal *Frida and the Abortion* (1932; Museo Dolores Olmedo, Xochimilco, Mexico City), a black-and-white, anatomically correct, self-portrait lithograph, created following a miscarriage in Detroit. Drawn to look like an image out of an old anatomical atlas, the lithograph presents Kahlo nude, suspended between light and dark, her transparent abdomen exposing the fetus she has just lost. Both she and Ixchel, Mayan goddess of the moon and childbirth (in the upper right), are crying. Kahlo's uterine fluid spills on to the ground, nurturing the roots of living plants. She draws herself with two left arms, one resting at the side of her body, and the other, raised, holding a heart-shaped palette. Kahlo is conveying that she is not a mother, but that she is a painter.

Frida Kahlo longed to be special. "I have always shared love with another," she told her friend Olga Campos in their interview.[14] In childhood, she compared herself to her sister Cristina, against whose bright-green eyes and doll-like features she came up short. It did not help when, in 1934, Rivera began an affair with Cristina and mocked Kahlo: "Look, the one I loved was your sister; you were just the doormat of my love."[15] In secondary school, Kahlo and a classmate shared an infatuation with Sara Zenil,

their gymnastics teacher. When Kahlo's mother discovered compromising letters, she transferred Frida to the Escuela Nacional Preparatoria, where the ratio of boys to girls was significantly higher. If Frida's sexual orientation was Matilde's concern, Frida was unaware of the problem. The issue was not her latent homosexuality but her insatiable hunger, driving her always toward acknowledgment, which was what Zenil had provided.[16]

Kahlo gradually took lovers of both genders in order to avoid feelings of emptiness. She deluded herself into believing that Diego Rivera would fill the void, but she was gravely mistaken: commitment to a human being other than himself was not among Rivera's talents. Kahlo had her first lesson in 1930, less than a year after their marriage, when it was rumored that Rivera had begun a liaison with his assistant Ione Robinson—the first of countless affairs. The following year, Kahlo began her own string of affairs. One of the first, with Hungarian-American photographer Nickolas Muray, lasted off and on for the next ten years. In 1940, the year she was divorced from Rivera, Muray would have married Kahlo, but she did not love him.[17] She had led him on because his interest helped her sustain a sense of worth that she otherwise lacked. As children do, Frida Kahlo sought gratification rather than satisfaction in relationships. In her mind, if she was not in a relationship, she was being rejected. While Kahlo had opportunities to love and be loved, she clung to the false belief that only Rivera held the power to give her a sense of self-worth. He also represented the one she could not have, and to win the impossible implied that she was extraordinary. This was the driving force behind Kahlo's pursuit of Rivera. Despite knowing better, she persisted and struggled but remained frustrated.

Kahlo's dependency on others for security and personal validation manifested itself early. She met Alejandro Gómez Arias in 1922 after entering the Preparatoria, where, as leader of the student body, he was the most powerful pupil. She pursued him unabashedly, becoming his pseudo-girlfriend and thereby winning acknowledgment that she might not have garnered on her own. At each step of the way, Kahlo begged Gómez Arias to love her, believing that compassion would entice him.[18] She made her exquisitely painted *Self-Portrait with Velvet Dress* (1926; private collection) for him, intending it to hang at eye level so she would stay on his mind. In the painting, Kahlo

wears an embroidered velvet dress, its neckline dropping low between her breasts—a most daring look for a nineteen-year-old Mexican girl in the 1920s.[19] Gómez Arias liked Kahlo well enough, but he was not interested in her romantically. Following the bus accident that nearly killed her in September 1925, Gómez Arias promised to stay while Kahlo recovered, but left for Europe after inventing an excuse. When he returned, he sought her out but, with Rivera pursuing her, she was no longer interested.[20]

Frida Kahlo nurtured the myth that at thirteen she had wanted to have Rivera's child, as she had told her horrified girlfriends.[21] There are several versions of their first actual meeting, which occurred years later. Apparently, they met formally in 1928 through the photographer Tina Modotti, a mutual friend and fellow Communist. Kahlo was twenty-one. Diego Rivera, twenty-one years older and the most famous artist in Mexico, was known not only for his talent but also for his extraordinary way with words. He, too, was a professional seducer, shamelessly telling others just what they wanted to hear. In Kahlo's mind, their complex attraction mirrored the fabled relationship between the Renaissance artist Paolo Uccello and the youthful Selvaggia, which had fascinated Kahlo in her adolescence. She found it romantic to relive the love story of these two personages, without considering its tragic implications: Selvaggia pursued the older, self-absorbed Uccello and, although eventually he acknowledged the girl, his attention was not enough, and she died from emotional starvation.[22]

One of Kahlo's most fruitful periods came during 1939–40, when she produced major works in response to Rivera's termination of their relationship. The open conflict had begun when Kahlo returned to Mexico in early 1939 after exhibiting in New York and Paris. She had gone at the insistence of Rivera, who claimed that it would be good for her art. This proved to be true, but Rivera's unspoken motive was to punish Kahlo for her affair in 1937 with Leon Trotsky, who had been a guest at their house. Kahlo had become involved with Trotsky to give Rivera a dose of his own medicine after his affair with her sister Cristina. She was no match for Rivera, who knew how much he could hurt Kahlo by merely withdrawing—a game he played with expertise. She was too dependent to fight him overtly, too frightened of being abandoned. He, on the other hand, derived too much pleasure from hurting her to let her go. Why give up the cat-and-mouse game, which he enjoyed so much? In his autobiography, Rivera explained,

"If I loved a woman, the more I loved her, the more I wanted to hurt her. Frida was only the most obvious victim of this disgusting quality."[23] He saw this as a "quality" rather than as a deficit or a defect. Not only had Rivera intentionally sent Kahlo off, but when she returned from France, he greeted her with a request for a divorce.

The Two Fridas (1939; Museo de Arte Moderno, Mexico City) was inspired by Rivera's rejection. In this double self-portrait, two painted Fridas sit, hand in hand. The one on the right holds in her left hand a miniature portrait of Rivera, from which an artery connects to her heart. The Frida on the left bleeds from an artery that even a hemostatic clamp cannot close: unloved by Rivera, she is dying.[24] Years later, writing in his autobiography, Rivera's only response to Kahlo's pain was to claim that the separation had been good for her painting.[25] The following year, faithful to the project of painting the significant stages in her life, Kahlo produced images related to the divorce. *Diego on My Mind* (1943; The Jacques and Natasha Gelman Collection of Modern and Contemporary Mexican Art) began as a portrait of herself wearing a Tehuana headdress, with a portrait of Rivera suspended on her brow to denote her obsession. By the time she finished it three years later, root tendrils spread like a spider's web from the flowers in her hair.

Lessons about Christian martyrdom that Kahlo learned in childhood and identified with emerged in two other paintings of 1940: *Self-Portrait with Thorn Necklace and Hummingbird* (Harry Ransom Humanities Research Center, The University of Texas at Austin) and *The Wounded Table* (page 83). Kahlo used the theme of a betrayed Christ as a point of departure, personalizing his attributes, portraying herself as the Woman of Sorrows.[26] Her identification with Christ and a message about her age imbues the works with tension: she was thirty-three, the age of Christ when he was crucified. In *Self-Portrait with Thorn Necklace and Hummingbird*, Kahlo's frontal pose resembles Christ Pantocrator, the "iconic depiction of the Resurrected Christ as Ruler and Judge."[27] Having unraveled a crown of thorns, an attribute of Christ's Passion, Kahlo weaves a necklace with the branches, the thorns digging deep and bloody into her neck and chest. Over her right shoulder sits the devil in the guise of a monkey, and over her left shoulder death in the form of a black cat. Butterflies in her hair refer to the Resurrection, while the dead hummingbird dangling from her necklace represents lost love.[28] Kahlo is saying: "Like a betrayed Christ, I have died for love. Like a betrayed Christ, love will resurrect me."

Leonardo's *Last Supper* (begun *c.* 1495; S. Maria della Grazie, Milan) was the model for *The Wounded Table*, which Kahlo set in the dining-room of her and Diego's house in Coyoacán, where she lived alone after the divorce. The scene takes place on a stage, with rich burgundy curtains pulled back to reveal a phantasmagoria. The human legs and feet of the pine table, flayed and damaged, are a metaphor for Kahlo's body, her cross to bear; the wounded table and the wounded Kahlo are one. At the table's center, in what would have been Christ's place, sits Kahlo, dressed in Tehuana costume. In place of her right arm is a clay prosthesis that extends an empty cup to the lips of her male partner, imitating a pre-Hispanic funerary terra-cotta from the state of Jalisco in Rivera's collection, featuring a couple and fired as one piece.[29] To Kahlo's immediate right is an oversized Judas wearing Rivera's overalls and surrounding Kahlo with enormous arms. His injured neck is splattered with blood.[30] Further down the table, Kahlo's niece and nephew, Isolda and Antonio, keep her company in this dreamscape. Sitting to Kahlo's left, an overgrown version of the papier-mâché skeleton toy that she used two years earlier in her still life *Pitahayas* (1938–39; Madison Museum of Contemporary Art, Wisconsin) looks disturbingly alive, with its sardonic smile. It plays with Kahlo's loose, hanging hair, just as Christ's scourgers played with his hair at the Flagellation. Next to the skeleton is Granizo, Kahlo's pet deer and alter ego.

After she remarried Rivera on December 8, 1940, Kahlo's life did not change. She told a friend she had suffered two accidents in her life: the bus accident that crippled her physically, and Rivera, who crippled her emotionally.[31] She spoke of Rivera as something that had happened to her, not as someone she had chosen. Moreover, as she sought explanations for her misfortune outside—not within—herself, chronic conflict wore her down emotionally and physically. As always, she felt torn and, rather than face, understand, articulate, and resolve the problem, she communicated it through physical symptoms, creating an ever-growing, vicious cycle, each time doing more damage to her body.[32] She regarded each illness as being rooted in a physical cause, not acknowledging or treating its psychological origin—a process without which she could not heal.

In 1946, when Kahlo's health took an irreversible turn for the worse, she created *The Little Deer* (private collection), her self-portrait as a wounded stag.[33] It is a visual rendering of her personal confusion and a complex explanation of why she was the

way she was. Her head fused with the body of a deer, Kahlo portrays herself as half-male/half-female and half-human/half-beast. She stands in the woods, her body pierced by nine arrows, with nine trees lined up to her right and lightning striking over the distant water. She is crying. A dry branch lies at her feet.[34] On a photograph of the painting that Kahlo gave Rivera, she inscribed, *I am a poor little deer.*[35] It is the first line of a song popular in Oaxaca in 1930, telling how a deer, thirsty for love, overcomes shyness and finds a way to meet his loved one.

In pre-Hispanic Mexico, every day was identified by a sign (there were twenty: Dog, Wind, Rabbit, Death, and so on) and a number (one to thirteen), and each thirteen-day cycle was associated with a deity. Thus, human and divine time became intricately related, and people attuned themselves to cosmic fluctuations, adapting to their beneficial or harmful energies.[36] Some dates promised success, health, or long life, while others made one vulnerable to ill winds, aggressors, illness, or an early death. Kahlo chose the deer, or *mazatl*, to represent her alter ego after discovering in the Aztec Native Anatomy of Divine Influences that the deer governs the right foot, the location of her disability.[37] But to be born on "Nine Deer" was not a good sign.[38] For the Aztecs, the number nine represented earthly and nocturnal things. Also, the underworld consisted of nine stages. The Mexican ruler Netzahualcóyotl (1402–1472) built a temple of nine stories for the nine stages that the soul must traverse before reaching eternal rest.[39] All the signs in *The Little Deer* point to the inevitability of Kahlo's predicament. The word *carma*, which she wrote on the painting's lower left corner, suggests that the cause of her unhappiness was deeds from past lives rather than something she had done in this life. "I cannot be fixed," she wrote in a note to accompany the painting when she gave it as a gift to the original owners.[40]

Frida Kahlo was not, as she indicated, thirty-seven years of age when she painted *Self-Portrait with Loose Hair*: she was forty, grieving the loss of her youth and contemplating the ravages of time on her face, with her loose hair a symbol of penance.[41] In pairing a succulent plant with a volcanic rock, she brings together life and death, once again retelling the story of her life, as in *My Birth*. The donkey's tail plant is so sensitive that even careful handling can damage it, causing its fragile leaves to fall. However, this succulent can survive long periods of neglect by retaining water and

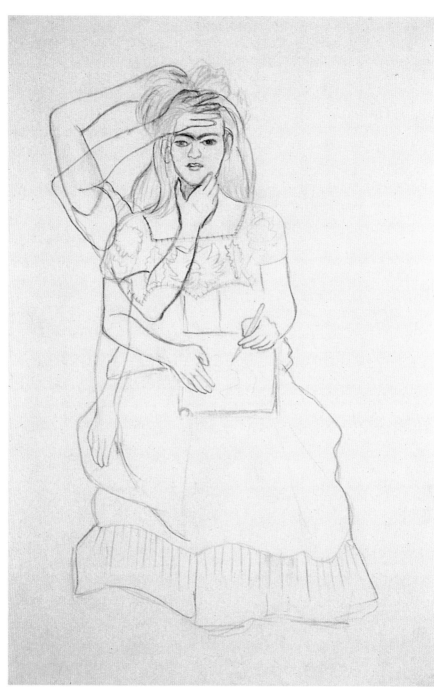

nutrients, feeding on itself. If, while painting *Self-Portrait with Loose Hair*, Frida Kahlo had wanted to create the work without distorting herself or misleading others by posing, she would not have been able to do so. By then, she had adopted the identity of "the great concealer," and attempting to reverse the process was no longer an option for her. By having chosen to walk into a mirror, Kahlo had, without realizing, entered a dead end from which there was no way out.

NOTES

1. The most complete documentation on Frida Kahlo's life is Hayden Herrera's *Frida: A Biography of Frida Kahlo* (New York: Harper & Row, 1983). Henceforth, Herrera 1983. I am deeply grateful to Hayden Herrera for countless generosities.

2. For a detailed history of Frida Kahlo's paternal ancestry, see Juan Coronel Rivera, "Guillermo Kahlo Fotógrafo," in *Guillermo Kahlo: vida y obra— fotógrafo, 1872–1941*, exhib. cat. (Mexico City, Museo Estudio Diego Rivera, 1993), pp. 27–110. Coronel explains that, at the beginning of 1906, Matilde Calderón de Kahlo "became pregnant for the third time. ... On this occasion, doña Matilde gave birth to a male, the first son of don Guillermo. Unfortunately, the boy died of pneumonia at approximately two months of age." Frida's birth in early July 1907 suggests that, assuming all pregnancies mentioned were full-term, she was conceived in October 1906. If young Wilhelm died around two months of age three months before Frida's conception, he would have been born around May 1906. The most specific documentation that has come to light on the son is a letter from Frida written on May 18, 1949, to a possible relative in Germany. In the letter she explains: "Only the boy died at age one." See Gaby Franger and Rainer Huhle (eds.), *Fridas Vater: Der Fotograf Guillermo Kahlo, von Pforzheim bis Mexiko* (Munich: Schirmer/Mosel, 2005), opening page. All translations are the author's.

3. Examples of other artists who have been "replacement children" are Salvador Dalí and Vincent van Gogh. In psychoanalytic literature, the replacement-child syndrome is covered from various perspectives: emphasizing the psychological damage to the surviving child; the idealization of the dead child; or the role of unresolved mourning by the parents. See W.W. Meissner, "The Van Gogh Family: A Study in Alienation," *Psychoanalytic Review*, vol. 85, no. 2 (April 1998), pp. 268–97.

4. Lucienne Bloch, Rivera's assistant and Kahlo's confidante, recorded in her diary how Rivera encouraged Kahlo to paint in Detroit, making a point of buying metal sheets for her. He told her to paint her life since birth, and to evoke the emotional impact of ex-votos. I am indebted to Lucienne Bloch and her husband, Steve Pope Dimitroff, another of Rivera's assistants, for sharing with me their Kahlo archives (September 1987).

5. From Parker Lesley's interview with Frida Kahlo, May 27, 1939, in the archives of the Centro Nacional de Investigación, Documentación e Información de Artes Plásticas (CENIDIAP), Mexico City.

6. Quoted in E.A. Wallis Budge, *Egyptian Magic* (New York: Bell Publishing Company, 1991), p. 162. The ancient Egyptians deified various forms of the same god, giving each a different name. Therefore, the bisexual, self-created god who emerged from Nun, the primordial waters of chaos, has other names.

Self-Portrait Drawing, c. 1937

FRIDA KAHLO: SONG OF HERSELF

7. Frida Kahlo, *The Diary of Frida Kahlo: An Intimate Self-Portrait*, introduction by Carlos Fuentes, essay and commentaries by Sarah M. Lowe (New York: Harry N. Abrams, 1995), p. 228. Lowe's interpretive comment links the statement in Kahlo's text to her artistry and sterility without mentioning the source of the quotation.

8. Teotihuacán was an important pre-Aztec city in central Mexico, and gave its name to the civilization that grew up there, reaching its height around AD 500. Kahlo's image appears to derive from a figure in Rivera's collection from Jalisco in western Mexico (*c*. 100 BC–AD 200), showing a nursing mother and infant with the body of a child and head of an adult. Kahlo chose the objects in her paintings very carefully, so the mask from Teotihuacán, a site known for human sacrifices, must have had a particular significance for her.

9. Letter from Frida Kahlo to Emmy Lou Packard, dated "Lunes 15 - 1941 Dic-." I thank Emmy Lou Packard, Rivera's assistant, for sharing with me her correspondence with Kahlo.

10. The many arms may derive from Kahlo's studies of Eastern philosophy and religion. In Buddhism, the many-armed Bodhisattva "is never born in any hell or in a degraded or deformed shape. Above all, the pain of constant sacrifice is overpowered by the joy of looking forward to the greatness of the reward, the attainment of power to enlighten others." Sister Nivedita and Ananda K. Coomaraswamy, *Hindus and Buddhists* (London: Senate, 1994), p. 259.

11. Olga Campos's interviews with Frida Kahlo, 1949–50, reproduced herein, pp. 55–111. Henceforth, Campos interview.

12. Campos interview; see p. 65.

13. Quoted in Herrera 1983, p. 51.

14. Campos interview; see p. 70.

15. Quoted by Emmy Lou Packard, interviewed by Katie Davis for "Frida Kahlo: Artist and Rivera's Wife," for National Public Radio's *All Things Considered*, March 10, 1990.

16. Campos interview; see p. 68.

17. Muray gave up the idea of marrying Kahlo in 1941 after his only child, a daughter, Arija, by ex-wife Leja Dorska, went to Mexico to work with Rivera and died after a short illness. Desperate to remake a home life, Muray promptly married an American, Margaret Schwab, and started a new family. Muray retained a non-sexual friendship with Kahlo that lasted until her death. I thank Mimi Muray for many conversations about her father.

18. Hayden Herrera takes the reader through the relationship between Kahlo and Gómez Arias in detail, reproducing many of Kahlo's letters pleading for his attention. See Herrera 1983, pp. 22–74.

19. For a detailed explanation of how Kahlo created *Self-Portrait with Velvet Dress* so Gómez Arias would not forget her, see Herrera 1983, pp. 60–65.

20. Herrera shows through correspondence from Kahlo to Gómez Arias that, when she returned from Europe, Gómez Arias was interested in Kahlo's friend Esperanza Ordóñez. See Herrera 1983, p. 80. Kahlo told Campos, however, that he insisted on seeing her until Matilde asked him to leave; see p. 70.

21. Bertram D. Wolfe, *The Fabulous Life of Diego Rivera* (New York: Stein & Day, 1963), p. 240. In this, his second biography of Rivera, Wolfe writes how he re-evaluated Rivera's misinformation in the first biography (*Diego Rivera: His Life and Times*, 1939), but he still included the story that Kahlo and Rivera met at the Preparatoria when she was thirteen. Herrera provides a chronology and dates the start of their involvement. See Herrera 1983, p. 80.

22. For an appraisal of Kahlo's interest in this story, as it applied to her life, see Salomon Grimberg, "Frida Kahlo's Memory: The Piercing of the Heart by the Arrow of Divine Love," *Woman's Art Journal*, vol. 11, no. 2 (Fall 1990–Winter 1991), pp. 3–7.

23. Diego Rivera, in collaboration with Gladys March, *Mi arte, mi vida* (Mexico City: Editorial Herrero, 1963), p. 224. Henceforth, Rivera and March 1963.

24. For Kahlo's interpretation of *The Two Fridas*, see MacKinley Helm, *Modern Mexican Painters* (New York: Harper & Brothers, 1941), pp. 167–68.

25. Rivera and March 1963, p. 176.

26. Isaiah 53:3 reads: "He is despised and rejected of men; a man of sorrows, and acquainted with

grief ..." Christians believe this passage foretells the sufferings of Christ; the phrase is described as referring to "anyone who has suffered loneliness, pain, or profound sorrow" in Eugene Ehrlich and David H. Scott, *Mene, Mene, Tekel: A Lively Lexicon of Words and Phrases from the Bible* (New York: Harper & Row, 1990), p. 158.

27. Diane Apostolos-Cappadona, *Dictionary of Christian Art* (New York: Continuum, 1994), p. 266.

28. For the symbolism of the butterfly, cat, and monkey, see Gertrude Grace Sill, *A Handbook of Symbols in Christian Art* (New York: Collier Books, 1975), pp. 16 and 18. Henceforth, Sill 1975. For the symbol of the hummingbird in pre-Hispanic times, see Carmen Aguilera, *Flora y fauna mexicana: mitología y tradiciones* (Mexico City: Editorial Everest Mexicana, 1985), pp. 49–50.

29. This piece is currently in the Museo Frida Kahlo, Coyoacán, Mexico City.

30. Like Leonardo before her, Kahlo refers to the Gospel of St. Luke in identifying the traitor in the painting: "But, behold, the hand of him that betrayeth me is with me on the table." Luke 22:21.

31. Personal communication to the author from Kahlo's confidante Gisèle Freund, August 1987.

32. The transformation of emotional pain into physical pain is a key subject in the medical literature on psychosomatic disorders. For a seminal study, see George L. Engell, "'Psychogenic' Pain and the Pain-Prone Patient," *American Journal of Medicine* (June 1959), pp. 899–918.

33. For a study of this painting, see Salomon Grimberg, *Frida Kahlo: The Little Deer*, exhib. cat. (Oxford, Ohio, Miami University, 1997).

34. Bernardino de Sahagún, missionary and Aztec archaeologist, documented that, from the sixth century AD, Nahuas placed a dry branch in the graves of those who had drowned or been struck by lightning. Upon arrival in Tlalocan, the place of delights, the branch would come back to life. Alfonso Caso, *El pueblo del sol* (Mexico City: Fondo de Cultura Económica, 1983), p. 80.

35. Rivera gave this image to Gisèle Freund. I thank her for sharing this information with me (August 1987).

36. Serge Gruzinski, *Painting the Conquest: The Mexican Indians and the European Renaissance*, trans. Deke Dusinberre (Paris: Flammarion, 1992), pp. 90–101. Henceforth, Gruzinski 1992.

37. For the Nahuas, there was a correlation between the body and the universe. It was believed that humans were imbued with energy that came from astral bodies, and that they had the potential to establish ties with everything in the world by imprecation or prayer; this was how the universe was humanized. Nahuas addressed hidden, invisible beings through a language called Nahuallatolli, or language of the hidden. References to connections between the human body and the universe are often mentioned in historical sources. For example, plate 1, xxiii, of the Codex Vaticano Latino 3738, an Aztec manuscript, shows a person with each of the twenty day signs connected to the part of the body that it rules. These signs influenced the health and life expectancy of a person. The deer, for instance, had an influence on the right foot (the one that Kahlo eventually had amputated). See Gruzinski 1992, p. 91. I thank Dr. Helga Prignitz-Poda for bringing this information to my attention.

38. "Nine Deer was not a good day sign. For whosoever was born on it, man or woman, nothing became one's fate." Gruzinski 1992, p. 101.

39. The soul then goes through a phase of transmutation before entering a new plane. See Burr Cartwright Brundage, *The Fifth Sun: Aztec Gods, Aztec World*, with illustrations by Roy E. Anderson (Austin: University of Texas Press, 1979), p. 212.

40. Quoted in Raquel Tibol, *Frida Kahlo: una vida abierta* (Mexico City: Editorial Oasis, 1983), p. 63.

41. "Long, flowing, and abundant hair can also be a symbol of penance, often worn by hermit saints (see St. Agnes, Mary Magdalene)." Sill 1975, p. 63.

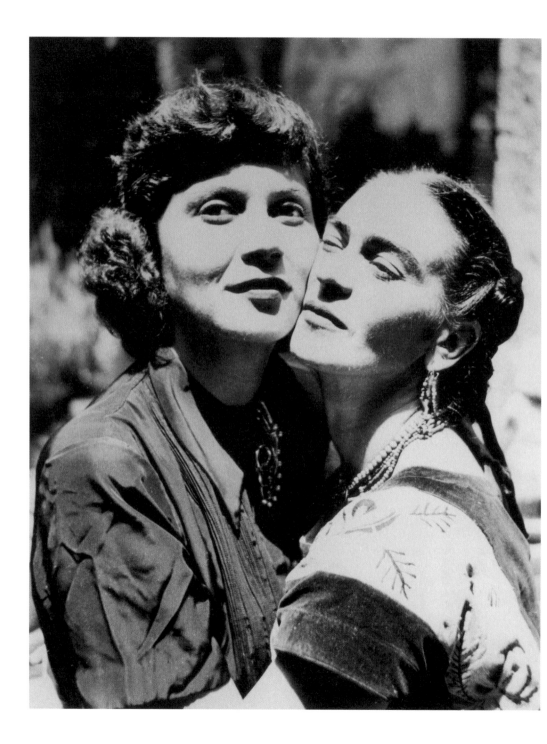

MY MEMORY OF FRIDA

OLGA CAMPOS

Translated by Salomon Grimberg from the original Spanish

I met Frida Kahlo for the first time on December 8, 1947. The occasion was a celebration of her husband's birthday. I remember the details of that day as if it were yesterday, despite the passage of forty-four years. I had gone to a bullfight with Jaime Barrios, a refugee friend from Guatemala. He asked if I wanted to go to Diego Rivera's house afterward; there was an open house for the artist's birthday in Coyoacán. I said yes immediately. I wanted very much to meet the renowned artist and his famous wife, the painter Frida Kahlo. Their art, their political ideas, their position in Mexico's cultural milieu, and Diego's scandalous declarations that he had eaten human flesh and found it tasty, had made them legendary. The whole world talked about them, it seemed.

We drove south and, as we turned left into the Viveros de Coyoacán, we ran into Lupe [Guadalupe] Rivera, Diego's daughter, who had been my classmate in the Escuela Secundaria. She too was going to the party, so together we went to the house on the corner of Allende and Londres streets, where a colorful and varied crowd stood impeding the passage of cars. We parked and crossed the street, cutting with difficulty through the human barrier to arrive in front of the house.

My eyes were dazzled by the spectacle. Diego and Frida sat like royalty on *equipales*—traditional wood-and-leather chairs from Jalisco—framed by the prop-like open doorway of the house. Standing behind and around them was a large group of friends, and in front, filling the street, were *concheros*—dancers dressed in gala regalia, covered with shells, and wearing large headdresses adorned with colorful feathers. They moved rhythmically forward and back to the sound of flutes and drums, offering homage to Diego, who accepted the tribute with a paternal smile. Frida looked beautiful, chatting with Diego. Like a queen, her head was crowned with colored

Frida Kahlo and Olga Campos, 1949

ribbons and flowers woven into her braided hair. She wore large gold earrings and a velvet ornamented cape that covered her shoulders. This same cape hangs today in the museum that was formerly the Riveras' home.

The sound of rattles and drums and the beat of the *zapateado* dance filled the air. The end of the ceremony was greeted with loud applause, and the Riveras stood to embrace the shell-dancers. The crowd on the street began to disperse, and Diego and Frida, holding hands, headed for the entrance of the house, followed first by the dancers and then by others—some guests, some onlookers, and some *gorrones*, or gate-crashers. It had grown dark, and the entryway was lit with colored lanterns, as was the pyramid that housed part of Diego's collection of pre-Columbian idols, and the patios and terraces. The doors leading to the interior of the house remained closed. The party was held outside. Near the pyramid with its pretty *palapa*, or palm-leaf roof, was a table decorated with paper cut-outs, where fresh fruit drinks, coffee with or without *piquete* (a shot of alcohol), and tequila were being served. Two more tables displayed trays with tacos, enchiladas, and tamales prepared to order by cooks in regional dress.

Diego and Frida sat on their *equipales* under a tree, where friends had formed a line that constantly circulated around them. When our turn came, we were greeted warmly. Sitting next to Frida was the painter Alice Rahon and, standing, Amelia Abascal, a young Spanish refugee, both of whom I had met before. I immediately felt more at ease, as if I had a certain right to be at the party. I stayed close to the Riveras and chatted with Amelia, who told me she now worked as Frida's nurse.

A small group of musicians, somewhere between a *mariachi* band and a town orchestra, played enthusiastically. Some people danced and others sang, but most gathered in groups and talked animatedly. Gradually the guests began to leave, until only about twenty people remained. One woman who also sported braids and wore an unassuming Tehuana costume took up a guitar and began to play. This was Concha Michel, a close friend of the Riveras. She sang old Mexican songs, some sad and melancholic, others unabashed and sacrilegious, and *corridos*—street ballads from the Mexican Revolution. She knew them all, and Frida made a fine singing companion. Diego kept requesting "El Caballerito" ("The Little Gentleman") over and over, and it was wonderful to see all these famous people having a grand time in a simple, childlike

manner. The time to leave came too soon, much to my chagrin. Amelia took my phone number, and Frida, who overheard, invited me to return. I promised I would, and kissed the cheek she offered. For the first time, I noticed the beauty of her scent: Schiaparelli. Maybe other women I had met had worn it, but it smelled different on her.

In those days I was a student of psychology at the Universidad Nacional Autónoma de México. As part of the curriculum, I worked two mornings a week, doing occupational therapy at the La Vista Psychiatric Hospital in Tlalpan [Mexico City], where I noticed that patients became more harmonious and attentive when drawing and painting. One day, after finishing work earlier than usual, I decided to visit Frida and Amelia, despite feeling a bit uneasy about not having a formal invitation. After much deliberating about how to approach Frida, I decided to show her drawings by my patients, using my friendship with Amelia. When I arrived, I composed myself and rang the doorbell. An enormous smiling giant came out. "I am Olga Campos, may I see Amelia?" I said.

Amelia and Frida were sunning themselves on the patio *de las ollas*—the one with all the pots— and they invited me in. Frida sat at a table with three of her *xoloitzcuintlis*, the Aztec hairless dogs I had heard of but never seen. They have no more hair than a small crest on their head and a tuft on their tail, and their skin shines as if it were oiled. They barked when they saw me, but Frida called them and they went to her, wagging their tails and dispersing the many doves on the patio. Frida was wearing

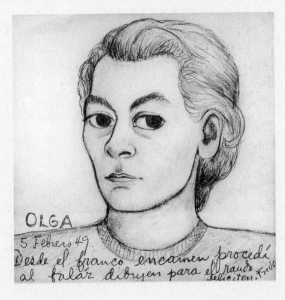

Portrait of Olga Campos, 1949

a long cotton skirt, fringed and printed in bright colors, and a ruffled blouse. Slightly made-up, she wore lipstick, and her hair was parted in the middle, braided, and put up on the nape of her neck with a yarn ribbon. She remembered me, smiled, and offered her cheek to be kissed; again, I smelled her perfume. She seemed pleased I had kept my promise to return, asking all sorts of questions about me and my work. When I showed her my patients' drawings, she seemed genuinely interested in what I had to say, asking many questions. I felt flattered and pleased. She invited me to stay for lunch, but I resisted, promising to come back each time I came to Tlalpan. Frida asked me to bring back the works of my "students" and to tell her more about each of them.

Initially, when I visited Frida and Diego I was received cordially, but in time, as the friendship developed, with affection. I grew to know Frida and Diego, every corner of their house, and their daily routine, so I often saw Frida's younger sister, Cristina, and her half-sister, Margarita, a nun, and the mirror image of Frida's father. Matilde and Adriana, the two older sisters, visited on Saturdays with Carlos Veraza [Adriana's stepson] in his eternal fedora, accompanied by his son, Carlitos. But Diego was a kind of erotomaniac. When we would meet, and Frida was present, he would try to kiss me and force his tongue into my mouth. He would get a kick out of my repulsion and Frida's reaction. Frequently, he offered to paint my portrait on condition that I posed nude. I refused each time, so he never painted me.

In the Riveras' home, I met and often saw Frida's intimate friend, the poet Carlos Pellicer; Guadalupe Marín, Diego's strikingly attractive ex-wife, with whom Frida shared an ambiguous complicity about Diego; Juan Guzmán, the German-born photographer who had made beautiful portraits of Frida; Jesús Ríos y Valles (Chucho Paisajes), Frida's childhood friend; the writer–historian Anita Brenner; controversial author José Revueltas and his sister Rosaura [the actress, dancer, and author]; the poetess Pita Amor, aristocrat and free spirit; Lina and Arcady Boytler, animal activist and film producer respectively, and devoted friends of Frida; Mexico's pre-eminent woman photographer, Lola Álvarez Bravo, and her son, Manuel; the poet and chronicler of Mexico City, Salvador Novo; American film actress Paulette Goddard; brilliant philosopher Antonio Gómez Robledo; mural painter Aurora Reyes; the director of the symphony orchestra, Carlos Chávez; and many others, both famous

and not so well known. Frida treated each person the same, regardless of economic status, intellect, fame, or beauty.

Cristina was Frida's right arm. Small, plump, pretty, and coquettish, with enormous blue–green eyes, she worked diligently and always seemed to be in a good mood. Each morning she would arrive at Frida's house ready to do whatever was needed that day. She would make out the market list and do the shopping. She helped Frida dress, comb her hair, and put on her makeup. She dyed Frida's gray hair, even when Frida was ill on her back. She helped prepare the food basket for Diego when he was painting frescoes or working in his studio. She would prepare enough food not only for Diego but also for his assistants, including starched napkins embroidered with flowers or doves carrying a message of love in their beaks. Frida would add personal notes with drawings on them. Frida and Cristina were incomparable sisters. They complemented each other, sharing their secrets, their sorrows and joys. "La Chaparrita"—"the little runt," as Cristina was usually called—was considered the so-called dumb sister and Frida the bright one in the family. Cristina was clumsy, Frida sensitive; one was the epitome of health, the other an invalid much of her life. Chucho, the smiling giant who had answered the door, was Frida's other confidant. Hilaria, his mother, had nursed them simultaneously. Frida called him "Nano Chucho," and to him she was "Niña Frida" or "the Señora." A strong man, in his youth he had been a boxer. Chucho made certain that the Niña's wishes were carried out as ordered. When Frida was unable to walk, he carried her like a child to the bathroom, to the garden, to her wheelchair. In the afternoons he would buy her a coconut ice cream or sherbet from La Siberia, the parlor in the plaza of Coyoacán. He also managed—when others had failed—to find her the Demerol to which she had become addicted for her chronic pain. After Frida's house opened as the Museo Frida Kahlo, Chucho, who was still the caretaker and lived with his family in the same room he had always occupied, disappeared one day. No one has heard from him since.

At first glance, Diego and Frida's intimacy seemed perfect, even enviable. They had similar interests in the arts and politics; they had a shared sense of humor and many of the same friends. They were also brought together by great tenderness. When intimate, they used the formal *usted* ["you"], and he would play the child and she the mother,

or vice versa. Diego would actually speak in baby talk at these times. One always seemed to know what the other was up to, and, on days when they did not meet, they wrote to each other to keep in touch. Whenever possible, he would call her on the telephone, and when he stayed in the San Ángel studio overnight, it was she who called.

Diego was funny, often letting his imagination carry him away. He would invent theories about how the Virgin Mary had conceived Jesus when she was pierced with a cosmic ray. He assured us this happened to other women, especially country women. Frida would pretend to take him seriously, neither refuting nor questioning Diego's fantasies. One could listen to Diego for hours: he was a great speaker and storyteller.

But deep down the Riveras' relationship had serious problems. Frida's physical weakness, her infertility, her uncontrollable jealousy and desire to possess Diego absolutely, clashed with his ways. He loved Frida but not as she wanted to be loved. Diego was restless and difficult to pin down. He was emotionally unavailable and continually unfaithful. In 1947, when I began my friendship with them, Diego was already involved in a steady relationship with Emma Hurtado, the woman he married after Frida's death. Emma accompanied him to public events that Frida could not attend, and she also sent baskets of food to Diego's studio. Amid all of this, he continued to have affairs with other women.

As far as I knew, Frida was not having sexual relations with anybody during this time. Frida was discreet and modest. She did not like to speak seriously of her intimacies or her illnesses, or even of her painting, which she considered unimportant. But I know she had a secret lover whom she adored. I do not know if it had always been platonic, but she carried on a correspondence with a Spanish refugee living in the United States, who wrote to her in care of the post office in Coyoacán. I would pick up the letters, addressed to a "Carmen" with a last name I cannot recall. When I delivered them, she would ask me to keep an eye out, *le échas aguas*, in case someone was coming. She would read and smile and kiss the paper, but she never read them aloud. I believe she destroyed them afterward. She would reply almost immediately, and ask me to put her letters in the mail right away.

It is widely held that Frida had an intense sex life, and I believe it. She certainly was a very sensuous person, and this is most obviously reflected in her paintings.

Diego, however, would say that he and Frida stopped having sex after they remarried. Nevertheless, when Diego slept in the Allende Street house, which was frequently, he slept on the other bed in Frida's room, and only occasionally in his downstairs bedroom.

Diego loved to talk about lesbians. He used to say he liked women so much he "must be a lesbian" himself: "Nothing is more beautiful than women and love, and this is best expressed when two women love each other." Once he was telling Lola Álvarez Bravo that her daughters were lesbians, and Lola was horrified—"Diego, don't say that!"—and he burst out laughing. He even bragged about Frida's homosexuality, and Frida told me she was attracted to dark nipples on a woman and repelled by pink ones. Despite this, I do not think she was a true homosexual. If she had sex with other women, I believe it would not have been for love or attraction but to satisfy her frustrated eroticism and vanity. She was also surrounded by more women than men; it would have been easier. She never flirted with me. She always showed me great affection, but homosexuality in the Rivera household was seen as natural. What mattered was the person, not the sexual orientation.

But it is difficult to imagine Frida actually having sexual relations because she was often so ill. For long periods she suffered from a pre-gangrenous condition in her right foot, and she had to maintain the leg, from the knee down, in a contraption kept warm by a lightbulb—a kind of incubator to aid her poor circulation. She was forced to wear a cast corset, and later, when she was in chronic pain after the amputation, she was sedated with painkillers. Despite her sensuousness, under these circumstances I think sex was really out of the question.

During the illnesses late in her life, Frida and I spent a lot of time together, and we grew closer. She would ask me to play store, *a la tiendita*. I would bring her Mexican sweets, such as *alegrías*, *pepitorias*, *peritas de anís*, *lagrimitas*, *chochitos*, or *charamuscas*. She had a special box made of glass and tin, still in the museum, which had dividers to separate the different kinds of candy. As if by magic, at a stroke, it would become *la tiendita*—the little store. Like a happy child, Frida would peddle her trade in a loud voice, calling the servants and selling the sweets "with a pinch and a bargain." It was a game in which we all participated and took pleasure.

When Frida felt better, if I had bought her a small toy, she would have a chair moved closer to the wardrobe with the glass doors and play dollhouse, or *casita de muñecas*.

One by one, the toys, dolls, and doll furniture would all be taken out and cleaned. Frida would talk and sing to the dolls while dressing them for a party to celebrate their *santo*, or saint's day. She would play school and take the teacher's role. Playing with her dolls, Frida would truly transform into a child, and afterward she would want to rearrange the order of the entire house.

Or we would play *teatrito*, little theater. In the dollhouse "lived" several rag puppets with clay faces, of the kind commonly sold in the market. Two or three were from the turn of the century, with porcelain faces, hands, and feet, and beautiful lace-and-silk dresses. One of these was Frida's favorite; I cannot recall why. We would take them out of the wardrobe and organize the play using the incubator as a stage. Even when Frida was not able to move the puppets, the play would go on, with one of the puppets representing her. We would invent dramas and comedies and accompany them with dialogue and songs.

When we played *putas* or *payasos*, whores or clowns, we would make ourselves up with pastel colors, fancy combs, and bright ribbons, and bet on the winner. I always lost. Now, writing about this, wondering why Frida played like this with me and not with other friends, not even with Isolda, her young niece, I question her motives. Why did she seek my company? I enjoyed her doing so, but it was seeing her so beautifully happy that made it worthwhile. During my own childhood, I never liked playing with dolls; with Frida I learned to like the game of make-believe. I will never doubt her genuine affection toward me, even though she may have used or manipulated me, as she did so many others. If she did, I really did not mind: she opened for me a world of beauty, of strength, and of love for nature and people.

When Amelia or more friends were there, we played Russian cards, a variation of the Surrealist game *cadavre exquis*. On a scrap of paper one person would write any phrase, fold the paper, and pass it to the next person to do the same. After each person had written his or her line, the whole page was read as one. This was more intellectual than the other games, but great fun just the same.

The childlike aspect of Frida's personality evoked tenderness in me. The games were not a silly, infantile way to exploit people, but a temporary escape from her painful reality—from her physical disabilities, her dependency on Diego, and her awareness of

living life to the fullest and nonetheless feeling empty. However, Frida did not spend her life playing or avoiding reality. On the contrary, she was very serious and struggled constantly with domestic, conjugal, and health problems; political intrigues; difficulties creating her painting; and her ongoing unstable economic situation.

The Museo Frida Kahlo as it stands today is cold and inhospitable. Apart from the walls, it bears no relationship to how the house was at one time. When Frida was alive, the doors and windows, which remain closed today, were kept open; light and people filled the rooms. The Riveras had many servants, including at least one family with two or three children who played in the garden near the pyramid. There were many *xoloitzcuintlis* that barked at the least provocation, and among them was the exemplary, most beautiful and intelligent Señor Xólotl, Frida's favorite. Frida slept with him on cold nights; he was her "hot-water bottle." In the morning he would sit before Frida or Diego, his ears alert, waiting for his master or mistress to greet him: "*Señor Xólotl, embajador, plenipotenciario de la República de Mictlán.*" "*How do you do, Mister Xólotl?*" "*¡Aquí!*" At this, the dog would raise his right paw to greet his mistress and happily walk away.

On one occasion I witnessed a terrible fight between the Riveras because of Señor Xólotl. Without consulting Frida, Diego took the dog to Emma Hurtado's house as a stud. Besides being Diego's mistress and owning the Galería de Pintura Diego Rivera, Emma also bred and sold *xoloitzcuintlis*. Frida knew about Diego and Emma's relationship and harbored no overt jealousy. She once told me, "Emma is a good woman, and she takes good care of Dieguito. She feeds him well, makes his underwear with *cambaya* cotton, and accompanies him when I cannot." She supposedly believed all this until that day. Frida could accept Diego's affair with Emma, but not his taking something as "personal and dear" to her as Señor Xólotl to the house of "that stupid, overly made-up woman." I do not remember ever seeing Frida more angry or indignant. She screamed, threw and broke objects, and sent all sorts of threatening letters and messages to both culprits. Diego disappeared from the house, and a few days later, with Señor Xólotl in his arms, he returned wearing the smile of a repentant, loving child, which Frida could not resist. Frida, as usual, forgave him, and peace reigned again in the Rivera house—until the next time.

Diego would be sought early in the morning by his helpers, the *maistros*, or construction workers; or by his students; or by vendors who took idols to sell to him; or by Ruth, his youngest daughter, an architect who helped in some of his projects; or by some rural group that needed his help in resolving problems with their land. Diego did not drive. The driver of his old station wagon, referred to as El General, also acted as a sort of secretary and caretaker to Diego, and a strong friendship tied these men to each other.

Frida ruled the house, organizing meals with Cristina's help. She personally arranged the vases with flowers cut from the garden or purchased in the market. Since she did not like being alone, she was constantly calling someone on the telephone to be brought up to date on gossip or to invite friends to visit. We were always well received whether we arrived with or without an invitation, but we respected her mornings, when she painted and attended to domestic issues. She liked visitors because she found the afternoons long and tedious. After lunch she would rest a good while and prepare herself for company.

The present-day entrance to the Museo Frida Kahlo on Londres Street was kept closed when the Riveras lived there, except when they gave a *fiesta*. Generally, the house was entered from Allende Street, where there was also a garage. In room number one, the current museum office, garden and construction tools were kept. During the time Trotsky lived in the house, his armed bodyguard occupied this room. The rooms marked two and three, where the public now sees Frida's paintings, were kept locked; they were filled with *idolachos*—the pre-Columbian idols that Diego was collecting for the Anahuacalli Museum, then under construction [in Mexico City]. Room four was a guest room that Frida sometimes used for days or weeks at a time. Room five was furnished with tables, chairs, bookshelves, and idols that had not been classified or were not very valuable. Room six was an informal dining area with a square pine table and a *trastero*, a dish rack. Room eight, the formal dining-room, is virtually unchanged, as is room nine, Diego's bedroom. He used it when he arrived late at night or had to leave very early, or if Frida's spare bed was occupied by the nurse or a woman friend. Room seven is the kitchen, although it looks as if it was no longer used as such after Frida became gravely ill in 1953. The room where Judas dolls cover the walls and floor

is room number twelve. This was Frida's studio, and is missing only the sofa bed reserved for her guests. Room thirteen is where the four-poster bed Frida used at the end of her life stood and where she died. The room now contains a small pine bed, four chairs, and decorative arts and crafts. It was also used as an informal eating area for Frida and Diego or Frida and a few guests. Frida ate downstairs when she felt well or on special occasions when they had many guests. Room fourteen, a sort of rickety bedroom today, held two twin beds and a mirror that Frida moved about constantly. This is where El General lived at one time. A large window in this room faces Allende Street. One could find a bit of everything here, according to Frida's changeable taste, and order reigned, with flowers and lots of light everywhere.

The patio with the pots, unnumbered in the house plan, was Frida's favorite patio for sunning herself and taking short walks. Doves used to nest in the pots, but the time came when there were so many that it became impossible to enter the patio without emerging covered in *coruco* [parasitic insects living in the doves' feathers] droppings and lice. The pots had to be sealed up with bricks, and the doves, no longer fed, disappeared. The patio that surrounds the museum has existed since before the marriage of Frida's parents, and was used as an open-air dining area when they had parties.

Though it was a house where love and joy lived, it was not a fairy-tale home. Fear of loneliness fed itself like a leech on illness and jealousy, with ugly confrontations and quarrels. A lot of money was constantly being spent, especially on Frida's illnesses, and later, in the 1950s, after his penile cancer was diagnosed, on Diego. Frida kept herself informed of his condition through Cristina, who nursed him and applied his treatments daily. Adding to their problems, Diego was overly generous and offered financial assistance to anyone who asked for it and to many who did not, and often was not repaid. He also had a compulsion for buying pre-Columbian artifacts. What he earned painting frescoes was not enough; he had to paint easel works—generally portraits—to make ends meet.

Frida expressed guilt for depending financially on Diego. I believe it was one of the reasons that she forced herself to paint, to contribute to the household. I never saw Frida cry in physical pain, but I did see her cry helpless with rage for being a financial burden to Diego. She wanted to be a true partner, and was always, not only in times

of crisis, the first to support him. She supported him unconditionally. When Carlos Chávez, as orchestra director and composer for the Instituto Nacional de Bellas Artes, vetoed sending Diego's mural *Nightmare of War and Dream of Peace* (1952) for exhibition in Paris, Frida became indignant toward this man, who had been their close friend for many years. She wrote him a scathing open letter that she asked me to edit for publication, but no newspaper would print it.

The letter I transcribe here exactly as Frida wrote it, with her idiosyncratic grammar and syntax:

Carlos Chávez:

Since when do you die with fear of the doves of peace? Or is it that you now belong to the fighting lions?

The stupid and cowardly attitude that you take in the case of the Exhibition of Mexican Paintings in Paris, especially in the case of Diego Rivera, places you clearly in the role of anti-Mexican, antidemocrat, and a subject of imperialism. Worse than that, you've become a small Quixote in search of Doña Blanca [a reference to "¿Dónde está Doña Blanca?," the Mexican version of "Ring Around the Roses"], Washington, D.C., covered in pillars of gold and silver. Didn't you find out that your own Mr. President rejected their little soldiers? Where were you? Did you expect Diego Rivera to paint a vase of roses and violets? You, who for thirty years have known his painting, who has praised it, who has been proud of it, have you forgotten? Or do you want to take for fools all the countries in the world, and your lords and masters, not to lose your job here so you can keep up a little contact with your good neighbors. The people of Mexico and North America and France will be your first and strongest critics.

France, if it has no dove, carries with pride the hat of "Liberty." Its friends from Washington exhibit the classic statue that France gave them at the entrance of their most grandiose city, and Mexico is giving you classes in intelligence. Your own president, whom you serve, would not be "put to sleep" by warrior pacts.

What do you have left? Playing the role of concealer of the culture of your own country, even of your own work, to compose a symphony to imperialism that will not be applauded by one or the other? This is the most abject and dangerous future of all opportunists.

As director of INBA, as you now are, you should show yourself a courageous man, little afraid of the opinions of other nations, because you are responsible for exhibiting the culture of Mexico as it is in its entirety. And, within the broad culture of Mexico, ancient and modern, like it or not, Diego is one of the highest exponents of painting.

You want to do an exhibition in Paris without Diego being represented by his latest works, which you requested he do with free rein, and now you come like a tray of spittle playing hide-and-go-seek with North American imperialism, writing Diego Rivera that your momma says she no longer wants it? I personally disavow you as exhibitor of the painting of my country, and, painter that I am, I protest before your attitude, and I will not agree to send any painting of mine to the said exhibition, even though my work is garbage within this magnificent group of Mexican painters. And if my work is shown with works lent by others, it will be exhibited against my will.

What has happened to your "tonsils," have they swollen so? It must be the sun from the "elite" of Acapulco? Naturally, that is another sun, very different from the one I learned from you many years ago in a song, "Sun round and red like a wheel of copper" Or is it the filthy shadow of imperialism that shelters you?

I hope my attitude will be followed by all my friends. As a comrade of the craft of Diego Rivera, I judge criminal that you commissioned him to paint this mural, which you made him work at to the point of exhaustion, taking advantage of his name at the beginning and backing down from sending his work at the end. Carlos Chávez, that is never done by a man with or without the three-cornered hat, with or without an eagle and a snake. It's the lowest I have ever seen in all my life. I am no longer your friend.

Frida Kaho [sic]

Among the things Frida enjoyed best was to go out for a ride. I had a car, so I would drive, and, when she felt well, we would go out to different parts of the city. We went to the Villa de Guadalupe and there bought *gorditas de maíz* [corn tortillas filled with cheese, pork skin, or pork rind], which she loved. We would turn back through Las Lomas de Chapultepec to see how the *riquillos copetones*, or rich bigwigs, lived. We would go to Xochimilco to buy flowers and plants. Other times, if she felt really well, we would organize picnics. In the house, a basket with *tortas*, sandwiches, and fruit was prepared, and we would leave for some place close to the edge of the city where we would eat, and cut wild flowers. Sometimes, it was the Pedregal de San Ángel, which was then an open field covered with volcanic stone. In Xochimilco, we would rent a *trajinera*, a flowered canoe. Frida would wear a straw hat, and enjoyed her outings to the hilt.

In time, Frida's illness worsened, and she began to need antibiotic injections every three hours. Someone was needed to give her these at night, and my nineteen-year-old brother, César, came to help out. When he arrived, Frida would have a tray brought up with large amounts of food that she made him eat, "because," she said, "he is too thin." They became *cuates*—pals—and he was also invited to the parties on Allende [Street]. She would always go when he called to invite her to a movie. She would arrive downtown by taxi, very pretty and well dressed. In her native clothes she could easily pass for a peasant woman visiting the city. They would go arm in arm. After the show, Frida would treat him to supper in a Chinese coffee shop, the kind they used to have around Bucareli Street. César would then accompany her home by taxi, also paid for by Frida.

Frida's face and body, and the way she dressed, have been made famous through personal photos and self-portraits. Her light-tan face was not pretty, perhaps, by established norms, but she possessed—and even radiated—a strange and alluring beauty. Her eyes were large and had a deep, questioning look. Her characteristic eyebrows were shaped like the wings of a bird in flight. She had a small, average nose. Her lips, though thin, were sensuous. She had a special skill for applying makeup and achieving a natural look, and spent a lot of time on this effect. She used blush and rice powder by Coty. Her lipstick and nail polish were always in a strong color, and, for her eyebrows and lashes, which she carefully combed, she used Talika black powder. She used Trushay hand lotion. She was always made-up and well dressed, even when she did

not expect visitors. There were only a few times I saw her without makeup. She customarily parted her hair in the middle and made two braids with ribbons or wool yarn woven through them. At home, she would let the braids fall down her back, but for dress-up she would raise them over her head, crowning them with a ribbon tiara, and adorning them with flowers or combs covered with rhinestones. She knew how to transform herself into a sensational beauty, irresistible and unique.

Frida wore lots of jewelry. For everyday, she wore medium-size silver earrings and a few rings. But when she dressed for a gala, she would wear large gold earrings, and Guatemalan marriage chains as necklaces, with beads or pre-Columbian figurines. On her fingers she would mix gold and silver. A small selection of her jewelry can be seen in a showcase at the museum. Her clothes were usually made of cotton, especially her daywear. Her petticoats were starched, her skirts were of stamped *cambaya* cotton, and her Tehuana blouses were usually frilled, laced, or hand-embroidered. Her clothes always smelled of the sun. When it was cool, she covered her shoulders with *rebozos*, or crocheted shawls. For special occasions, she wore luxurious clothes, such as the velvet cape exhibited at the museum, or exquisite skirts and *huipiles* [long cotton tunics] from Oaxaca embroidered in silk.

Saturdays were visiting days. In the morning, Frida's sisters Matilde and Adriana arrived with Carlos Veraza and his son, Carlitos. Sometimes, Frida's nun sister [Margarita] came too. They usually stayed for lunch, and Carlos would drink his tequilas, leaving early in the afternoon before the friends arrived. Aurora Reyes and Concha Michel, whose son carried her guitar, Jesús Ríos y Valles, Juan O'Gorman [an architect and painter], Anita Brenner with her daughter Suzi, the painter Antonio Peláez, and María Félix—all were frequent visitors, and Diego was nearly always present. Our drink was tequila, and our common ground was singing, singing, and more singing. Part of the fun was inventing new lines to the "San Marqueña," "El Pobre Venadito" ("The Poor Little Deer"), or "La Llorona." It was a contest, and Frida often took first place. "If once I loved you, weeper, it was for your hair, now that you are bald, I don't love you anymore"; Frida wrote a modified version of the chorus on her *Self-Portrait with Cropped Hair* (1940; The Museum of Modern Art, New York), which she painted after Diego divorced her. We drank moderately.

No one got really drunk, and Frida hardly drank at all. She told me there was a time when she did drink a lot, but that was before I knew her. She may have cut down because she was so often on antibiotics, and alcohol inhibits their effect. The fiestas usually came to an end between nine and eleven at night. Frida tired easily, and Coyoacán was far away from the city, with few transport connections.

To live with Frida and, for obvious reasons, with Diego, was to live on the razor's edge. I witnessed chilling quarrels between them, as when they espoused political issues, not only via Communist groups, but also via other Leftist movements, such as Paloma de la Paz, or Dove of Peace. For this cause, they got a group of us collecting signatures from their friends and from people on the street. Likewise, Frida and Diego responded to injustices in other countries and crises within the Mexican Communist Party. Although Frida belonged to the party, she was not a militant. Diego had been thrown out of it, but they shared the same ideas. Diego remained a Communist to the marrow. The Riveras were always in crisis: if it wasn't their love that was in question, it was their health, their finances, or something else.

Late in 1948, Diego came home with the news that he had met María Félix, and he was going to do her portrait. Frida became excited with the idea, and together they planned a meal for the film actress, who was the star of the moment and considered in Mexico to be the most beautiful woman in the world. Earlier, María had married Agustín Lara, the number-one composer in Mexico. The press got all stirred up, nicknaming the couple "Beauty and the Beast." María had a weakness for ugly men that no one could understand.

Looking dazzling, María arrived at the house with Rebeca Uribe, her personal secretary and intimate friend. The luncheon was served in the main dining-room in an atmosphere of exhilaration. María and Frida took to each other immediately, and Diego was obsequious with them both. From then on, María became one of the regulars, visiting Frida often at weekends. She sang, in a very distinct, deep voice, songs from the north of Mexico. María's presence lent glamour to the Riveras' parties, and many more people came, filling Frida's bedroom with cigarette smoke and laughter.

One day, I received an anguished call from Frida urging me to come immediately. I arrived and found her very agitated. That morning, after Diego and María had

arrived, María had asked Frida in a very sweet way to divorce Diego so the two could marry. Thinking it all a joke, Frida agreed, laughing, but it turned out they were serious. Diego told Frida he had come to pack his clothes, and was moving in with María. Frida could not pull herself out of a state of shock. She was shaking with rage, though surely she knew there had been something more than friendship between Diego and María. Taking revenge, she called the newspapers to inform them of the "illicit" relationship between her husband and María Félix. The news broke on the front pages, causing great scandal among Mexicans, who were not as liberal then, and who sympathized with the abandoned wife, condemning the sinful lovers.

In all, Diego's stay at María's lasted a little more than three weeks, just long enough for him to finish the portrait, in which María wears a translucent dress. María threw Diego out, and would not even let him take his brushes or easel, but told her servants to pack his belongings and leave them on the sidewalk. Then she called Frida and told her it had all been a joke. Frida accepted her explanation, but the friendship cooled, even though, on the surface, it seemed as if nothing had happened. When María's personal secretary died following a cocaine overdose just as María was about to leave for Spain to film, Frida, feeling stable physically, allowed Amelia, her nurse, to accompany María.

Soon afterward, Frida began having trouble with her back and consulted Dr. Farill, who suggested a surgical implant in the spine. This would not only cure the backbone, he said, but also aid circulation in her right foot. Frida was admitted to the American British Cowdray Hospital, then located where the Hotel Camino Real is today. But the implant did not take hold, and complications followed. The wound did not heal, continually becoming infected, and Frida remained in hospital nearly a year, during which time she underwent six or seven more surgeries.

Frida's hospital room was similar to the others, but situated at the end of a corridor, facing the hospital gardens. Soon the incredible happened. Diego began spending the night, sleeping on the narrow extra bed and bringing so many things he soon took over the next room, turning it into his general headquarters. Gradually, Frida's room and corridor were covered with Communist posters and Judas effigies. The *tiendita* was brought in, and Frida's brushes and paints. And visitors began to file through. It was

not long before someone smuggled in a bottle of tequila for the "healthy" guests. Not one more month had gone by before movies were being shown: Arcady Boytler sent a large projector, a folding screen, and 16mm films, along with a projectionist nicknamed El Güero, "The Blond." In time, he and Frida became inseparable (though, for some reason I was never told, the relationship ended abruptly and she felt deeply betrayed). Gabriel Figueroa [Mexico's most acclaimed cinematographer] would bring films, too. Arcady made sure that each day a new film was shown, regardless of whether Frida had been operated on in the morning and was still feeling groggy from the anesthetic. The show began promptly at four. Patients from other rooms began to show up on foot and in wheelchairs. Friends, nurses, even some doctors, such as Armando Navarro or Velasco Polo, would arrive too. Viewers filled the room and spilled out into the corridor. Sweets were passed around and, if someone wanted it, even a shot of tequila. Amid her illnesses, Frida was happy.

Around midday, Cristina or Chucho would arrive with one of their famous food baskets. Frida never had much of an appetite and would not touch the hospital meals, but she would have some ethnic food brought from home. It was always a special dish, heated up on an electric range, plus tacos, *tortas*, Mexican sandwiches, and fresh fruit. Diego sometimes stayed for lunch, and there was often enough to share with nurses and doctors. Frida's room seemed like anything but a hospital room. On the days when she had surgery and was only semi-awake, we took care to limit the number of visitors, and our voices and the volume of the film or radio were kept low.

Through a small window in her corset, Frida's friends and onlookers such as myself would observe her wound being cleaned each morning. We would describe for her the color of the wound and how the edges were growing. Frida seldom complained or commented at all. The nurses administered Demerol, which made her sleepy and then helped her wake up euphoric but with her usual frank and generous smile. It was a sight to see her painting the various corsets that she wore during the months in hospital. We all participated in their decoration. Some only bore signatures; others were painted with such tinctures as iodine, methylene blue, and Merthiolate. Frida used cotton applicators as brushes, or her own paints and brushes brought from home. She decorated the corsets with mirrors, painted flowers, and fruit, or with the hammer

and sickle or political slogans. We would hold up mirrors to help her see what she was painting on the front, or on the back after the corsets were removed.

Each time Frida went into the operating room, Cristina carefully combed her sister's hair and powdered her face. She would stay until Frida was under anesthetic, emerging with a handkerchief in her hand that held Frida's dental bridges. After surgery, only Cristina was allowed in Frida's room to dress her and help Frida reinstall her dental bridges. Frida's modesty and coquettishness prevented her from showing herself, even to Diego, without her teeth.

Some months before this hospital stay, I had begun to carry out a battery of psychological tests on Frida, and she dictated to me her autobiography. She also created, at my request, a series of non-objective drawings in pastel that depicted her emotional states. Hate is drawn to resemble a flower, a cannibal flower; Pain, like a flame, rises and devours (page 64); Love grows in red, broken, anguished lines (page 65); Laughter is a symphony of circles, spirals, swirls, yin and yang (page 60); Mirth is a tissue of life, with cells and suns (page 62); Peace, a wheel of somber color swirling darkly around a center of yellow (page 59); Panic, a deep-purple wheel, a jagged-edged saw (page 58); Disquiet, a sunburst of yellow–black growing out of the center of an elliptic disc (page 66); in Anguish, black rays break out of a circlet toward other circular forms (page 63); in Jealousy, black-lined triangles intersect yellow rings; and in Rage, red and black triangles grow out of circles within circles. Frida may have wanted to draw Freedom. She was, after all, a prisoner of herself.

In this test, of my creation, I intended to establish points in common among artists who used line and color to express comparable aspects of their personal life. I applied it to several painters, but the project grew too big for my knowledge and economic means. Years later, I reluctantly sold Frida's and Diego's drawings to Bruce Rogers, a friend in San Francisco.

After Frida recovered and left the hospital, El General had to make several trips in the station wagon to transport back to the house on Allende Street all the things she had accumulated during her stay. I accompanied her in the ambulance, and she talked of projects and plans for the future. She was certain she was over all her ailments and, as soon as she got home, she began her *retablo*-like *Self-Portrait with the Portrait of Dr. Farill*

(1951). She was grateful for her improved health and felt indebted to him. Afterward, she painted several still lifes to help cover her expenses and debts. Although she had some back discomfort and her foot never healed, Frida derived comfort from being surrounded by people: Cristina and her children, her sisters, the pianist Ella Paresce, the photographer Bernice Kolko, Concha Michel, and Jesús Ríos y Valles. She even let bygones be bygones with María Félix, who had returned from Spain and was visiting her again.

One afternoon, Frida received a visit from Agustín Olmedo, one of the Cachuchas—Frida's group of childhood friends from the Preparatoria [named for the distinctive berets they wore]. I had met him before and, in connection with the psychological testing, thought it would be interesting to let him speak freely about Frida.

"I met Frida on the street," he said. "She must have been fourteen years old, more or less. She looked scared. I had never seen anyone like her, and I got the impression that they did not know how to dress her at home. I saw her as a small child. I talked to her, but she would not answer because she was frightened. ... Our friendship developed because she was around those guys the Cachuchas, and they were my friends. Afterward, I tutored her in mathematics, but even so she remained scared. I was hard on her." "*Rete duro*," Frida added—"real hard."

"Yes," Agustín continued, "but I wanted to see if she would give up her fear. Frida looked a bit anemic then, malnourished, and her fear seemed to go from the physical to the mental. She used to think she knew a lot of things but, little by little, she began to question everything; this was part of her fear. She was not sure of herself in anything, not with people, not in her tastes, and not in her way of looking and seeing the world." Then he looked at Frida: "For me, Fridita, you were in limbo."

"I think, in general terms," Agustín added, "she has never known what she wants in real life. She changes her mind every day. She still has not lost her haunted look. Before, when she did not know what to do, she would ask me and I would advise her. When she was run over ... I think I had a good influence in helping her tolerate what she was going through. I helped her protect herself by giving her moral support." Frida responded, "You helped me a lot when my arm would not move, and you surrounded me with a ray of light." "In some things," Agustín finished, "she has not changed; she is still walking in limbo."

Soon after that afternoon, I moved to Acapulco, but I remained in close touch with Frida by telephone. We cried together when she told me her leg was to be amputated. This time, I could not be physically present with her. On July 6, 1954, I called to wish her a happy birthday. She sounded tired. I told her I was coming to Mexico City and would visit her in a few days. She told me she would be waiting for me. "Bring me seashells so I can hear the sound of the sea," she said before hanging up. This was the last time I heard her voice.

I arrived on July 12 and did not call right away. The next day, I went to the Merced Market and, by chance, called home. Mother answered apprehensively and said, "Go to Coyoacán. They just called to say that Frida died." Stunned, I sped to the house on Allende Street. Outside, there were many cars. As I ran up the stairs, I bumped into Diego. We hugged and he said in a low tone *"venga a ver"*—"come see." Gently, he led me by the arm to the room next door. There, Frida was lying dead on her bed, made-up and coiffed, wearing her *huipil* from Yalalag. She looked as if she were asleep. Without thinking, I bent over to kiss her cheek, as I had done so many times before. I felt something on my lips. I looked and saw Frida's facial hair was standing on end. I kissed her again and again, and the sensation was the same; even the hair on her arms stood up. I screamed over and over, "She's alive, she's alive!" In a state of hysteria, I was taken to the kitchen, where Lupe Marín and Lola Álvarez Bravo gave me a tranquilizer with some tea. I remember being quiet when Diego had Frida's veins cut with a scalpel to confirm her death, but I cannot recall how I got home. I did not attend the homage to her that was given at the Instituto Nacional de Bellas Artes, nor did I attend her cremation. I could not believe that Frida's life was over. Although many years have gone by since Frida passed away, I often think of her, of her courage, but especially of her privileged way of enjoying beauty—and life.

Mexico, August 1991

Olga maravillosa ..., 1949

INTERVIEW

WITH

FRIDA KAHLO

OLGA CAMPOS

Translated by Salomon Grimberg from the original Spanish

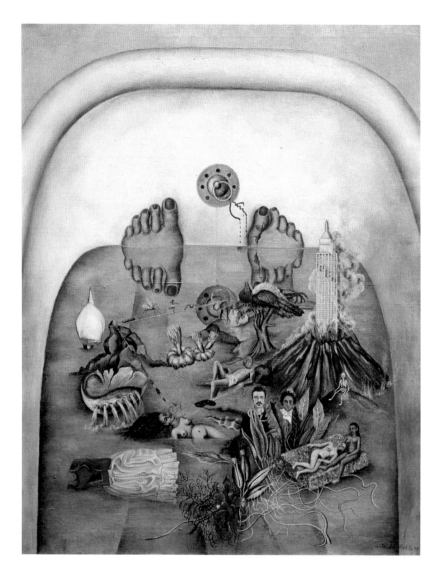

What the Water Gave Me, c. 1934

In *What the Water Gave Me*, Kahlo reflects in a visual metaphor on what life gave her: one destructive experience after another. Although it is generally believed that *What the Water Gave Me* was painted in 1938 (and signed and dated 1939, after it was acquired by Nickolas Muray), one publication suggests it was likely done in 1934, after Rivera began his love affair with Cristina Kahlo. In a letter to Alejandro Gómez Arias, dated October 12, 1934, reproduced in *Escrituras de Frida Kahlo* (ed. Raquel Tibol, 1999), Kahlo describes various details for a planned painting that appear in *What the Water Gave Me*: "I have not been able to organize the parade of tarantulas and other beings ..." The description refers to the insects and other personages parading on the tightrope that is choking her as she is drowning.

MY LIFE

I was born at 1 am on July 7, 1910.[1] I studied up to Prepa,[2] have no religion, and I am of the Mexican race, or better to say I am a mixture.

My father was a photographer, my mother worked at home. My maternal grandfather was also a photographer. My sisters [were] untrained in any special skill. One is a nun. I never lacked the essentials at home, but we were more poor than rich.

My mother was named Matilde Calderón y González, the daughter of a Mexican father and a Spanish mother. She died in 1932 and was born in 1880.[3] She was thirty years old when I was born. She suffered epileptic attacks, which may have been psychosomatic since they began with the menopause. She died of liver sickness the day after an operation, and I was not there. Although I came especially from Detroit to see her, I did not make it in time to see her die.[4] I always had a lot of compassion for her. The poor thing was in love with another German, named Luis Bauer.[5]

My father was named Guillermo Kahlo. He was a German immigrant, born in Baden-Baden in 1870.[6] He suffered from epilepsy, and died of a heart attack in 1941.

Papá was an atheist, Mamá Catholic. Papá was a Germanophile, and Mamá leaned toward Porfirismo.[7] Papá was the only one at home who read—scientific, geography, and history books. I am in agreement with everything my father taught me, and nothing my mother taught me.

My sisters, in order of age, are: [María] Luisa, single and the daughter of my papá; Margarita, single and a nun, also my papá's daughter; Matilde, married, my sister by my father and mother; Adriana, the same; after Adriana there was a boy, who died at birth; me; and Cristina.

In my house, Papá and Mamá slept in one bedroom, my older sisters in another, Cristina in one, and me in another.

As a child, I had playmates. We played movies, store, dolls, hopscotch, top *et cetera*. I was always enrolled in public schools, and spent only six months in the German school. They threw me out because I would not sew or do as I was told. They were mediocre but secular, and that seems good to me.

In the first year of my life the [Mexican] Revolution started, and I was aware of what was happening. Everywhere there was talk of the fall of Don Porfirio [Díaz], of the Zapatistas, of the Villistas, and all that.[8]

I was eleven months old when my sister Cristi was born. I was breast-fed by Chucho's mother, Hilaria, and another nursemaid, but I do not remember her.[9] Listening to Mamá talk, I heard that she washed the breast of the nursemaid very well before she gave me milk. I think I suckled for close to one year.

I remember a rocking chair, when I was about four. Sitting in my mother's lap as she rocked me, I had a very nice sensation.

When I was three or four years old, I entered a kindergarten close to our house. Delfina [the maid] would take us in a little carriage. I liked to watch Delfina while we were riding and so did Cristi, and because of this we would fight furiously.

The teachers were named Julita and Lucesita. I paid 50 centavos for tuition each month, and Cristi paid 1 peso because she was always getting into trouble. They would teach us such children's songs as "Lindo Pescadito" ("Pretty Little Fish"). There they taught me about the earth and the universe with an orange and a lighted candle.[10] I did not make trouble; rather, I was dumb. I urinated in my pants, and they made me wear the underwear of the Turati girl, who was the daughter of the owner of the factory in front of our house, and it made me so angry that I wanted revenge, and I waited for her to walk past the house, because I wanted to kill her. After that I hated her.[11]

Pánico (Panic), 1949

They sold some candies in the Casa de la O that were rosaries made of sweets made by some old ladies, and they cost 1 centavo.

They tricked us with the story of the Three Wise Men, but I caught one uncle of mine putting a long stick candy in one stocking, and I never believed in the Three Wise Men again.

I remember vaguely the house of my godfather, named Marcial Vargas, who was in the military; afterward they told me he had died in action. I do not know what rank he had. Was he a policeman? I would cherish greatly his visits to our house because he would bring me sweets. I remember one day crying under the bed because one of my socks was torn. I did not want to come out and be seen by my godfather, who was bringing me chocolates.

I remember the first scolding my mamá gave me because I stuck out my tongue at her. I do not remember why. They spanked me, maybe because they had sent me to do something and I did not want to do it.

I remember my grandma, that she loved me very much and I loved her, too. I felt pity for her because she had a glass eye. I once asked her why she had a marble for an eye. She hugged me and began to cry, the poor thing.

I spent almost every afternoon at my grandma's house because she had a lot of newspapers and magazines. Mamá and other people would go to church to say the rosary, and they would leave me there and pick me up later. My grandma had a cuckoo clock, and the window of her house faced Allende Street.

The first quarrels between Cristi and me were because each week one of us would get the white wardrobe that had one mirror shaped like a moon. The week Cristi had it, it was always dirty and messy, and I always kept it very clean. When it was going to be her turn, a horrible anguish would come over me. That was my first triumph: Mamá said whoever made the best embroidery in school could keep the white wardrobe

Paz (Peace), 1949

forever. But I cheated: a girl in school embroidered me an apron for Mamá that had little faces around it and little woven waves, and in the middle an islet with a red ribbon that the teacher put on it. I paid the girl 5 centavos each time she helped me. That is how I won the white wardrobe.

At that time, Cristi got scarlet fever. I remember the smell of lavender and disinfectant. They would not let me in her bedroom. It was our first separation. I felt very sad, very, very sad. I started to cry sitting on the sidewalk. I felt belittled. One day, I was able to go into her bedroom, and Cristi gave me a little painted chest full of centavos, and I left very happy. When they found it on me, they gave me a bath and spanked me.

One day, my grandma's maid combed my hair and gave me lice.

Márgara Kahlo has been in the convent since she was two.[12] She came to visit from time to time, once or twice a year. I would have been four or five when she first visited, and they put us in the same bedroom, and she was very loving toward me. No one had ever told me stories, and she was the first one who told me "Little Red Riding Hood," "Sleeping Beauty," and all those fairy tales.

One time, in the night, I wanted to make *pipí*, and she held me while I was doing it and told me that I was not the daughter of Papá and Mamá. I remember it gave me a lot of sadness. I cried and she cuddled me in bed and continued telling stories to console me. After that, I liked locking myself in the dirty clothes basket. The idea that I am not the daughter of Papá and Mamá has never left me.[13]

Before that, there were some poor children who went to the same school as me and lived opposite us, in a small hut. There was one who could not talk well, who could not pronounce well. I would make him count from one to ten and he could not do it. I threw him down on a pile of cow caca; I dragged him through it and got him all dirty.

I remember very well the cook of the house, Flora, a chubby, small-town woman, and I was enchanted with how she dressed in her skirts and blouses embroidered in rickrack. In the afternoons she would embroider a bead blouse. I always wanted to finish eating quickly so that I could watch her embroider. The blouse she made for me had a colored eagle and, underneath, it said *Viva México* and *Fridita*. One Sunday, they put it on me with a little skirt that she had also made.

Risa (Laughter), 1949

I always wanted to be older than I was because my older sisters had sewing kits with pincushions and I did not. They were not used as pincushions but to store little things. Mamá and Papá would bring Cristina and me toys from their trips away from home, little pots and dolls, their faces, arms, and legs made of porcelain, and their bodies of sawdust. I wanted to grow up so I could play with the dollhouse and put the little toys in it. The years seemed eternal, and I would say "when I am eight" as if it were one thousand. One of my favorite games was playing with dolls that were not mine but Mati's [Matilde's]. The dollhouse was hers, too, but she would let me play with it. I had eyes only to watch my sisters play with dolls. My sister and my cousin played with them in the basin, sometimes sending the doll children to Europe in a little boat. On one occasion, I stole Juanito, the boy doll, from them, and I hid it so they would not take it away. I still have it; it is in the wardrobe.

Until we were older, ten or twelve, Cristi and I stayed together. I began public primary school, and I do not remember anything about the first year. It was when I entered primary school that I became a tomboy. They would say, "Frida is a little strange."[14]

Mamá punished Mati a lot. They would put her in the room that afterward became my first little studio. There was a broken window and, after she was punished, I would stick bread through it for her. She was a real flirt, and up to two or three boyfriends would come around at one time.[15]

Alegría (Mirth), 1949

One time, Mamá took out of the basement a nest of rats in a doll's wig and quickly drowned them in the basin. She also killed a puppy in the basin, and I never forgave her.[16]

I often remember Papá in the living-room playing piano, Viennese waltzes, and I loved to go in and sit and watch him play.

I remember very well a Christmas when Mati sang in German. There was an enormous decorated pine tree. I got as a present a little carriage with a boy doll dressed in blue. Cristina got a very pretty thing, and I wanted to trade. But it was not possible.

I was fascinated by Papá's studio. I would help him wash, crop, and press photos and afterward sell them, when we were poor. When I was in Prepa, they would send me to help my father when he had epileptic attacks.[17] After school, I would go to his office, which was downtown, and accompany him everywhere. I would also do my homework there, and he would help me. I remember the fear that Papá's epileptic attacks made me feel. Cristina and I would hide under the bed.[18]

I remember when Mati was the girlfriend of Guacho Muñoz, who was a real bastard. His sister had tuberculosis, and we were not allowed to go to their house. But I was friends with his younger sister, and I went in and saw her looking like a dry stick. I was panicked with fear of tuberculosis.

Also, I remember my first sailor suit: a pleated skirt, winged hat, and sailor blouse. Oh, how I cherished wearing it the first time.

Angustia (Anguish), 1949

I was very impressed by the First Communion—Cristi and me with Father Castro—and the First Confession. [The church] stank of incense. One day, before Communion, they sat us down to ask Mamá for forgiveness. I lost my head. I cried and cried because we had never done anything bad to her.[19]

I was very ugly, and my dress was very ugly, without pleats, and Cristi's was very pretty, and I was very envious of her. I was eight, and the First Communion was enormously emotional for me; I did not know anything about anything, but the ceremony made me emotional. The same would happen when I would offer flowers to the Virgin. Oh, I would love it. I was really ugly, and I had an admiration complex for Cristi. They sent us to the house of Señora María y Campos for instruction. I remember one afternoon, while they were teaching, I asked about the Mysteries of the Bible, and I think I behaved badly so they sent me to a retreat. It was the usual thing: "To dedicate oneself more to God," as Adriana would say. It was a house where one spent about fifteen days. They had clean sheets and mattresses on the floor. I asked the priest so many questions about how Christ was born, and was the Virgin really a virgin, that they threw me out. They threw me out for spoiling it for the other kids.

At that time, the churches were closed because of the Revolution, and Mamá would invite the priests to give Mass in the house. The schools were also closed, and Mamá hired a teacher to teach us fifth and sixth grades. The teacher almost choked on a brew that Mamá gave her. Matilde had already married. It was very funny.

I liked Lupe Paul [a friend of the family] to visit. She was a lady who would bring joy to the house. She would tell us jokes and stories.

Also, Rodolfo Sana [another family friend]; he gave me lots of 5 centavo coins. He was the first one who took me in an automobile. On Sundays he would take us out for a ride. There was a cart pulled

Dolor (Pain), 1949

by two horses and one man who was missing both legs. One day Rodolfo hit the horses and they reared.

I had my little playhouse with puppets and charged 1 centavo, and six kids would go in and buy *charamuscas*, brown-sugar candy twists. I invented a game called "la agonía de un cabo" ["the agony of a candlewick"], about a candlewick that people stared at until it went out.

At the yell of "the oak table!" we would race from school to win the place next to Mamá. After each meal we prayed.

I was the most complacent of the daughters, and the one who was nicest to Mamá. I always accompanied her to see the missionaries and the priests. But I must tell you that by this time I no longer believed.[20]

There was a hairless holy woman in the church. She was in mourning. And I fell back stunned when I saw her bald.[21]

I remember the first time I was sick. I had gone to play with a boy, Luis León, and on the patio he threw a wooden log at my foot, and this was the pretext they used at home when my leg began to grow thin.[22] I remember they said that it was a white tumor or paralysis. I missed a lot of school. I do not remember a lot, but I continued jumping, only not with the right leg anymore. I developed a horrible complex, and to hide my leg I wore thick wool socks up to the knee with bandages underneath. This happened when I was about seven years old, and my papá and mamá began to spoil me a lot and to love me more. The foot leaned to the side, and I limped a little.

This was during the period when I had my imaginary friend.[23] I would look out of the small glass panes of the window and fill them with steam. Then, I would draw a little window and go out through it. Opposite our house, there was a milk store that was named Pinzón, and I would travel from the little window through the "o" in Pinzón, and from there into the center of the earth, where I had my friend, and we would dance and play. If I was called at that moment, I would go behind a tree and hide, and I would

Amor (Love), 1949

INQUIETUD

laugh, very happy. I do not remember my friend's house, and she had no name. She was like me in age. She had no face. The truth is, I do not remember if she had a face or not, and she was very lively. I could not describe her.

Other times, I sat on the small steps that faced the stone patio. There was an oven for baking bread in front of the kitchen, and I would make believe that I saw little boys and girls dressed in pink coming out of the oven. They would come out in groups and then disappear. It gave me so much pleasure. This happened several times. Every time I saw the oven, they ran out, always dressed in pink.

OCTOBER 8, 1950

In school I liked geometry class because everybody would draw very pretty angles and spheres in colors. Geography I liked a lot, too, as well as history.

The first time they threw me out of class was because I told a friend to bring some rags and paper, and we began to make curls. I was not afraid that they would tell my mamá.

Around that age I began to ask how children were born, and a girl whose brother was a doctor brought in some color plates. I remember standing in front of the house of some friends of Mamá, and the girl took out the plates where you could see how children were born and told me that it was "so you won't make a fool of yourself," and a lady came to the window. I went running and did not get to see the plates, and I remained curious.

I loved lying on the grass, especially in the places where there were little puddles, and I would imagine they were lakes, and there I built the world.

At that time I began to play hooky from school, and went to the Pedregal [the Pedregal de San Ángel, an area of lava field to the south of Mexico City], which I liked very much. Sometimes Cristi would come, too. I remember everything so well I could draw it. One time, next to a small hut, a dog came out and bit me, and I did not go back. In my house they would say it was very dangerous for children to go to the Pedregal. I liked going alone to walk and walk.

Inquietud (Disquiet), 1949

OCTOBER 27, 1950

The fifth- and sixth-grade group that studied in my house was taken to be tested at the public primary school, and I came out well. Then came the conversation between mother and daughter of "What will you do with your life? I think the best thing is for you to study trade or to become a teacher." Since I did not know what I wanted, I chose the usual: the school for teachers in the Mascarones building, which was exquisite. Since I had never left Coyoacán, Papá would take me and bring me back from school each day.

I began to be very tomboyish, and when I entered sports class, Señorita Sara Zenil examined me and told me that, because I had had polio, I could not do the exercises, and I began to withdraw from the other children. I fell in love with her. She was very affectionate. She would sit me on her lap, and during the gym hour I would go to her room to help her note the names of the other children and their physical examinations.

I became very friendly with Ana Carmen del Moral and Lucha Rondero. During the ten-day vacation, we would write letters to one another about what we had missed at school while playing hooky, and my mother found the letters. She called me into the dining-room and explained why I should not go around with people she did not know or approve of. I did not take any notice, and resolved to hide the letters better. At the end of the year, Señorita Zenil's mother died, and we three girlfriends stole a wreath and took it to her just so we could see her. The three of us were in love with her, and we were jealous of one another. I remember her skin and her perfume. Now I acknowledge that it was very corny. She taught anatomy, and I made a ten.

I also liked the astronomy class given by Lolita González de León.

The school gave a party, and all the children were in *The Blue Bird*, a play by [Maurice] Maeterlinck. My part came out horrible. The play was put on by Señorita Josefina Zendejas, and she told another teacher, "This girl has talent but we need to dress her up so her leg won't show." It already bothered me a lot, the thing with the leg. Aurea Prosel [a classmate] brought me a regular skirt with a *huipil* and told me to wear bows in my braids.[24]

They took me out of teachers' school because of my infatuation with Professor Zenil, and I entered the Preparatoria. I did not want to go, and I entered very fearfully. I would

escape to see Zenil. Another aspect of the teachers' school was that I felt very proud that I went into Mexico City and Cristina did not.

In 1922, I entered the Prepa. In the beginning I did not like it, but afterward I grew to love it. That has been the only happy period of my life. The problem was the timetable; one had to go upstairs with the girls. That bothered me, so I would escape and I fell in with a group called Los Cachuchas, whose ringleader was [Alejandro] Gómez Arias. They were not Communists, but liberals. They were lazy and they never studied, except for José Gómez Robleda, who was very hardworking, and Alfonso Villa. The whole group had a lot of admiration for Gómez Arias, who was very learned and had read a lot and traveled through Europe and the United States. The Cachuchas group was formed of Alejandro Gómez Arias, José Gómez Robleda, Jesús Ríos y Valles, Alfonso Villa, Miguel N. Lira, Manuel González Ramírez ("El Pueques"), and me. Satellites of this group were Carmen Jaime, Ernestina Martín, Agustín Olmedo, Ángel Salas, Renato Leduc, and Fernando Campo. The berets we wore were made by Gómez Robleda of brown checkered cloth. I was accepted out of pure fondness, because women were not admitted. Gómez Arias was the speaker. In school he always participated in all the meetings and all the trouble. Chucho Paisajes [Jesús Rios y Valles] was Gómez Arias's tail.

The school principal was Lombardo Toledano, and we threw him out of the school.

Until then, I had really not read anything. I owe them [the Cachuchas] for getting me interested in literature of all types, about everything. I was loafing around in class. I was with the boys everywhere they went and involved in all their pranks. Instead of going to my classes, I went to theirs. They were in their last year, and I did not learn either their classes or mine. In the four years that I was in the Prepa, I did not learn anything. I read only what the guys told me to, and I barely passed classes, or I cheated to get good grades.

My papá had his office above La Perla, and I would eat with him and return to school later.[25] Then Papá began his bad period. He was very ill, and he suffered a lot to earn money to pay for the house. Sometimes I would miss class because I had to help him. One time, because he did not have the rent payment, the Dieners were going to seize Papá's office, and Alejandro [Gómez Arias] went and fixed it all.

I fell in love with Gómez Arias and he with me. All the others respected me as a sister. They called me "little sister," and they would beat up anyone who said anything mean

Frida tahlo 31,

to me or bothered me. Gómez Arias and I were sweethearts. But Alejandro was in love at the same time with Chucho Paisajes, whom he screwed. Chucho Paisajes and I would talk of our mutual infatuation with Gómez Arias, and we would give each other advice. Chucho Paisajes, to this day, continues to be in love with him. It does not seem bad to me that Gómez Arias screwed Chucho Paisajes. I have never had anyone who loved only me. I have always shared love with another.

I first met Diego while he was painting the amphitheater, and I would really cherish going to see him paint.[26] [The artist José Clemente] Orozco was also painting in the Prepa, and I remember one time a group of kids wanted to scratch the paintings of Diego and Orozco.

My menses came to me in class, and a male friend took me to the nurse's office. It made me feel disgust and shame, and I told my papá.

Gómez Arias took care of me during that time. I had not developed at all, and, when Gómez Arias would take me home, he would kiss me and recite verses to me, and he would say that he had seen my breasts grow. I was in love with Gómez Arias, but I was very flirtatious, and I also liked Olmedo and Rogerio de la Selva. Gómez Arias would become horribly jealous. I wanted Gómez Arias to rape me. But he preferred to tell me nice things, to kiss me and hug me.

Every day we went for ice cream at a stand opposite the law school. And there, every day, I would see Lupe Marín carrying Pico, sometimes with Diego.[27] Sometimes Diego himself would pass by, and we would tease him. One day they asked me who I wanted to marry, and I said I would not marry, but I did want to have a child by Diego Rivera.

I was already in a cast, after the accident, and Gómez Arias told me that an uncle was going to take him to Europe and that he would not leave me, but he lied to me.[28] I received a letter from him from Veracruz saying he was leaving. It hurt me very much. When he returned, I did not love him the same and by then I really liked Diego. Alejandro made a jealous scene because of Diego in front of my mamá, who became very angry and hit him with a broom.

Diego was married to Lupe in the church, and I would spend nights thinking and thinking about who I would marry.

Triple Self-Portrait—as a toddler, adolescent, woman, 1931

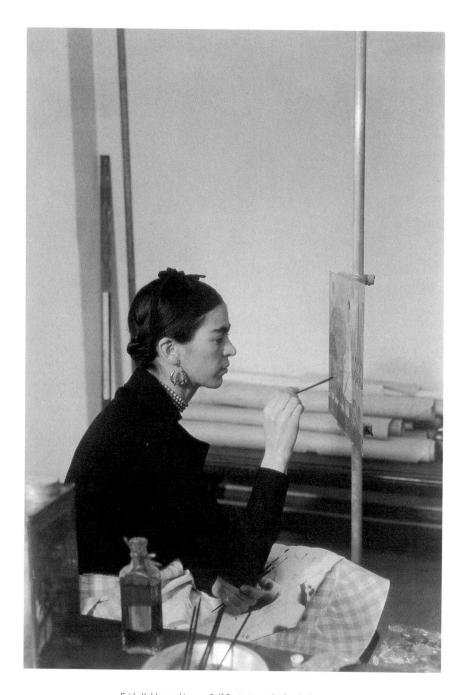

Frida Kahlo working on *Self-Portrait on the Borderline*, 1932

MY PAINTING

I was already interested in painting when I was about twelve. I was about fifteen when I began to draw. I have the first drawing, a self-portrait that I did in 1925.[29] I began to paint after the accident. I made the self-portrait with the clouds,[30] and the portraits of Adriana Kahlo,[31] [Miguel N.] Lira,[32] Alicia Galant,[33] Cristina Kahlo (page 80), and Agustín Olmedo.[34] All, more or less, are from the same period. With the last ones, I was wearing the cast corset. I would get out of the bed and paint at night.

Papa painted small landscapes by the river in Coyoacán, and copied sentimental paintings in watercolor and oil. Afterward, he gave me a little box of paints that belonged to him. Ángel Salas gave me a small book that told me how to prepare the canvases, and I made them smooth, smooth.

The courtship with Gómez Arias lasted from 1922 until 1925, when the bus crushed us both. Gómez Arias brought me books on painting and painters from Europe. These were the first books on art that fell into my hands.

José Clemente Orozco and I would travel on the same trolley from Coyoacán to Mexico City, and I would carry his papers. We became pals, and I invited him to the house. I had painted four or five things when he visited, and he gave me a hug and said I had a lot of talent, and he chatted on about the horrors of Diego.

There was beginning to be talk about Diego; that he had returned from Russia and was giving talks on Russian theater and art. I would go to hear him. Afterward, he

Self-Portrait (Here I am sending you my portrait so you will remember me), c. 1920

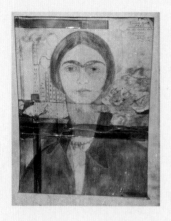

began to paint at the Prepa and later at the Secretaría de Educación.

I was studying at the Prepa, but the accident messed me up. I returned to school, but I felt very sore and had little strength. I took my paintings to Diego, and he liked them a lot, most of all the self-portrait. But of the rest, he told me that I was influenced by Doctor Atl [the Mexican painter and revolutionary, born Gerardo Murillo] and by [the painter Roberto] Montenegro, and that I should try to paint whatever I wanted without being influenced by anyone else.

That impressed me a lot, and I began to paint what I believed in. Then, the friendship and almost courtship with Diego began. I would go to see him paint in the afternoon, and afterward he would take me home by bus or in a Fordcito—a little Ford that he had—and he would kiss me.

One Sunday, Diego came to the house to see my paintings and critiqued all of them in a very clear manner, and he told me all the possibilities he saw in them. Then I painted two or three things, which are around the house, that to me seem very influenced by him. They are portraits of thirteen- or fourteen-year-old kids. The portrait of Rosita (opposite) that Mati sold to an old clothes dealer, Mr. [Salomon] Hale [an American friend of Rivera's living in Mexico, who was known for his fine eye for acquiring art] found in the Lagunilla flea market and bought for 8 pesos.

In 1929, I joined the Communist Party, I got married to Diego, and I had my first abortion. In that year I painted a portrait of Cristina Moya, which I still have;[35] the nude of a German cousin;[36] the drawing of a Greek mask, which I copied out of a book (left);[37] and other drawings that Morillo Safa [Eduardo Morillo Safa, Kahlo's main patron] owns. The unfinished [self-]portrait of my first abortion was my first Surrealist painting, but not completely [Surrealist].[38]

Top: *The First Drawing of My Life*, 1927 Above: *Greek Mask*, 1929

I have it. Jackson Phillips from New York bought the portrait of Salvadora and Herminia (page 78).[39] He paid me 300 pesos.

We moved from the house on Reforma [Street] to Coyoacán, and that had an enormous influence on me. How we painted the house and the Mexican furniture, all that influenced my painting a lot. While still on Reforma, I painted a self-portrait that is owned by Morillo Safa.[40]

Once in Coyoacán, I began to make paintings with backgrounds and Mexican things in them. I painted the portraits of Hale's sister (page 77),[41] of Guadalupe Marín (page 76),[42] and the one of Diego,[43] which I did not finish. Those three paintings, who knows where they are.

Morillo Safa has the third self-portrait, showing me bald and sitting in a cane chair.[44] I made a portrait of Gómez Arias on wood (page 81),[45] and others, but I do not remember what they were of, or who has them.

In 1930, I took my first trip outside of Mexico. I blubbered and blubbered. We were near San Francisco. There, I painted only a little: the portraits of Diego and me together, holding hands, now in the collection of the Golden Gate Museum [San Francisco Museum of Art];[46] Jean Wight;[47] a black woman who was a model of Diego's;[48] and the drawing of Lady Hastings, which is very good, a very close likeness.[49]

In Detroit, I painted a very ugly painting that gives me a lot of sadness when I see it, of a showcase with many things in it,[50] and one of my second abortion, in the Henry Ford Hospital;[51] both are in the Morillo Safa collection.

In the same year [1932], I returned to Mexico because my mamá was dying, and here I painted nothing. Then we returned to Detroit, where I painted *My Birth*, owned by Kaufmann [the industrialist Edgar J. Kaufmann, Sr.] from Philadelphia. We went to New York, to [Diego's] exhibition at the Museum of Modern Art, and back in Detroit I made a painting I gave to Dr. [William] Valentiner, curator of the museum in Detroit.[52]

Portrait of Rosita, 1928

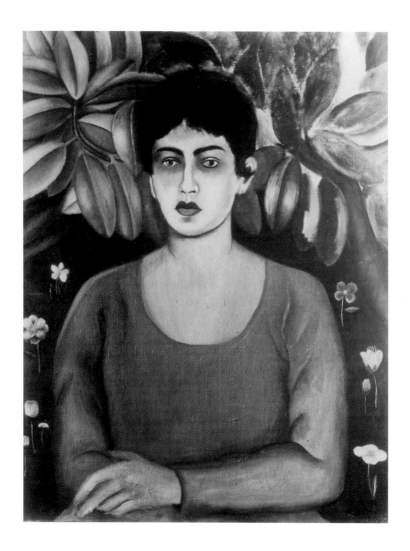

Portrait of Lupe Marín, 1929

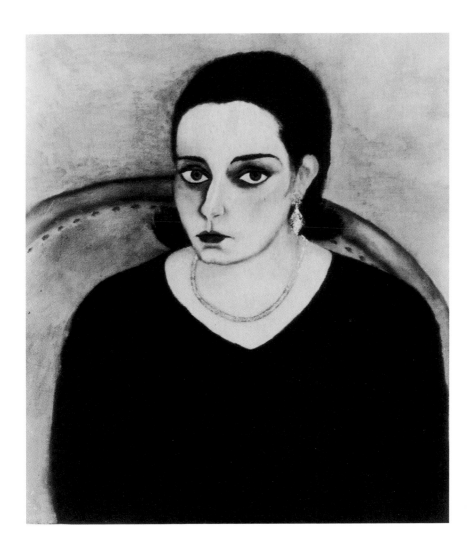

[Portrait of Salomon] Hale's Sister, 1930

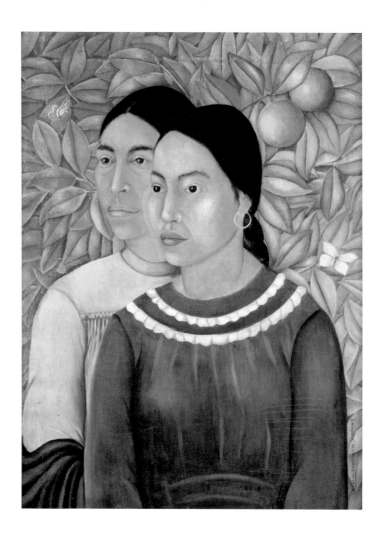

Portrait of Salvadora and Herminia, 1929

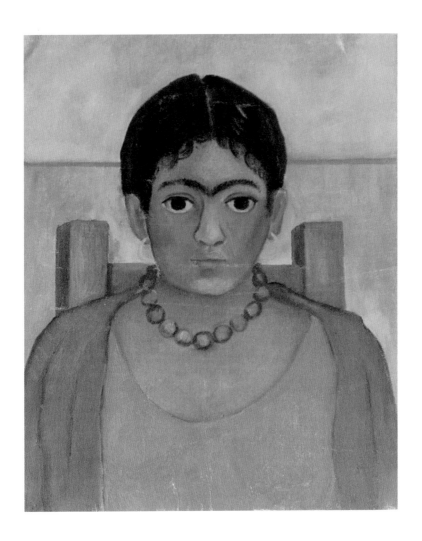

Girl, 1929

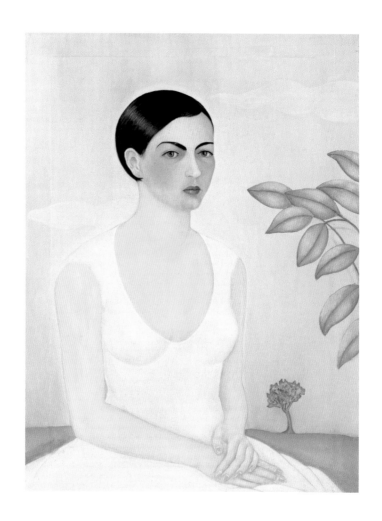

Portrait of Cristina Kahlo, 1928

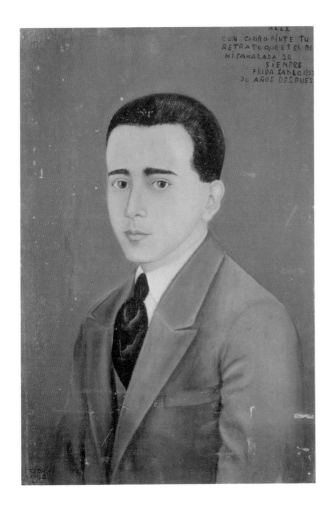

Portrait of Alejandro Gómez Arias, 1928

In 1933–34, I was very interested in political things.[53] I painted almost nothing: my small self-portrait,[54] the portrait of Diego,[55] and an airplane crash (below).[56] Edward G. Robinson has them and another painting of mine.[57] By then I had returned to Mexico.

In 1935, I went to New York and did nothing: I painted *Me Alone*.[58] Here began the most awful suffering. At this time, the first divorce that did not happen was planned. I returned to Mexico, and lived in the house on Avenida de los Insurgentes, and Diego stayed in San Ángel.

From 1936 to 1938, I did nothing but paint. In 1938, I had my exhibition in New York. With the money that Robinson gave me, I paid for my trip to New York and from there went to Paris, where I also exhibited. I did not paint anything there. I just had a high time and was idle.

When I returned to Mexico, all the trouble and mess with [Leon] Trotsky happened, and Diego and I divorced. I began to paint more seriously, and I did not throw away my paintings because I got paid money for them. I made portraits of [the composer] Carlos Chávez,[59] [the film star] Dolores del Río,[60] and others; also one of Nickolas Muray [the American-Hungarian photographer, Kahlo's lover].[61]

I think I painted myself more or less ten times. One self-portrait belongs to Mary Sklar (she has two of my paintings);[62] another is in the collection of A. Conger Goodyear.[63] *The Two Fridas* [1939] is in the Museo Nacional [Mexico City, now the Museo de Arte Moderno]; *Now That I'm Bald You Don't Love Me* is in the Museum of Modern Art [New York].[64] In *The Wounded Table* (opposite), I am alone at the table next to a *judas* and an *ídolo* that I am feeding. I gave it to the museum in Moscow.[65]

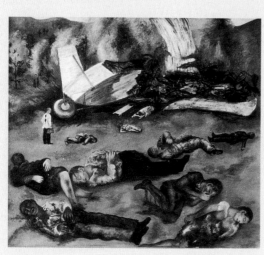

The Airplane Crash, 1934

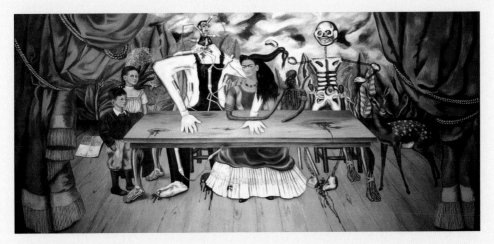

A self-portrait in bed was another, and, since I did it when I did not want to eat, I painted it with a funnel.[66] Morillo Safa has it. *Tree of Hope Stand Firm* [1946] was bought by Dr. Carrillo Gil, a friend of Inés Amor's.[67] *The Little Deer* [1946] belongs to Arcady Boytler.[68] One self-portrait is Mrs. Florence Arquin's;[69] and the engineer [Eugenio] Riquelme owns the *Embrace to the Earth* [*sic*].[70]

I painted portraits of Marte R. Gómez[71] and of the Morillo Safas;[72] the *Flower of Life* [1943];[73] and Helena Rubinstein has one still life.[74] The engineer José Domingo Lavín has the *Portrait of Marucha Lavín* [1942][75] and *Moses* [1945], one of my nicest paintings.[76] He gave me Freud's *Moses* [*Moses and Monotheism*, 1939] to read, and he told me to do a painting about that.

For a period I drew in brown ink. Bartolí [Josep Bartolí, Kahlo's lover] has some of these drawings. I tore up some and kept others.

The Wounded Table, 1940

House in Harmony, 1947

MY PARENTS

I remember the color of my father's skin—that I did not like it. My mother's fatness was also unpleasant.

I was impressed by my father's hands and by my mother's eyes and eyebrows.

My oldest memories [are] of my father, an attack of epilepsy, of hearing him speak; sitting in the rocker on my mother's lap.

I remember how they were.

My father was benevolent and severe, rather violent but very kind-hearted; mother, benevolent.

My father never offended or hurt me; my mother did, twice.

My father explained to me my school lessons and would give me German lessons, [accompanied by] smiles; and he gave me my first set of paints at sixteen. Mother was a friend to the Zapatistas and would save them. She helped many people, some unknown.

My father gave me little pats on the head, never kisses. My mother was very loving in every way. She would say, "My skinny one, my Friduchita."

Because of his will, I greatly admired my father; but not my mother.

My father was strong, but tough. She was not strong.

I often saw him ill; I rarely saw my mother ill, but when she was, she was very sick.

I saw him dead; I did not want to see her dead.

He was attractive, a very fine type. She, too, was pretty.

He was gifted intellectually; she was, too, but uneducated.

I loved my father because he was good to me, because he helped me. I loved her because I saw her suffer very much.

I was never afraid of him; I was afraid of her scolding.

I was never afraid they would hit me.

Guillermo Kahlo, n.d., and Matilde Calderón, n.d.

Frida Kahlo.

MY BODY

The most important part of the body is the brain.

I am not dumb; my memory is very bad; and I am very sensitive. My health is the worst. I do not consider myself very weak, but I would like to be stronger.

It is hard to picture my future. Until I feel well, I cannot think about it.

I am not especially afraid that something will happen to my body. I am calm about the thought of injury or sickness.

It is a marvelous thing to have eyes; touch is very important.

Of my face, I like the eyebrows and the eyes. Aside from that, I like nothing. My head is too small, my breasts and genitals are average. One leg is skinny and one is fat. No part of my body is perfect, my right leg least of all. My walk is the worst.

I think I have well-developed sexual characteristics. I have the moustache and in general the face of the opposite sex.

I give secondary importance to my sexual potency.

Self-Portrait Wired, 1949

Retrato de Irene Bohus

MYSELF AND OTHERS

I would like others to think that I am useful; to give the impression of cleanliness and beauty; to come across as intelligent.

I do not like to be considered religious. I like people to know that I am not.

Physical strength is very important.

I would like to be physically stronger, not weaker.

I would defend myself with the first thing I could find against someone stronger who attacked me.

I am satisfied with my relationships.

Sometimes one dominates without seeming to.

Sometimes I am interested in and affected by opinions about me.

I am frequently offended and hurt.

People who give themselves airs are foolish and vain.

People exaggerate my qualities.

I do not compare myself often with others.

I am quite inept in getting to know the character of people.

All types of people interest me, but I am attracted to the intelligent ones.

I have no heroes.

Of actors, businessmen, or politicians, I admire actors. I admire the artist.

Diego exerts more authority than I do.

Portrait of Irene Bohus, 1947

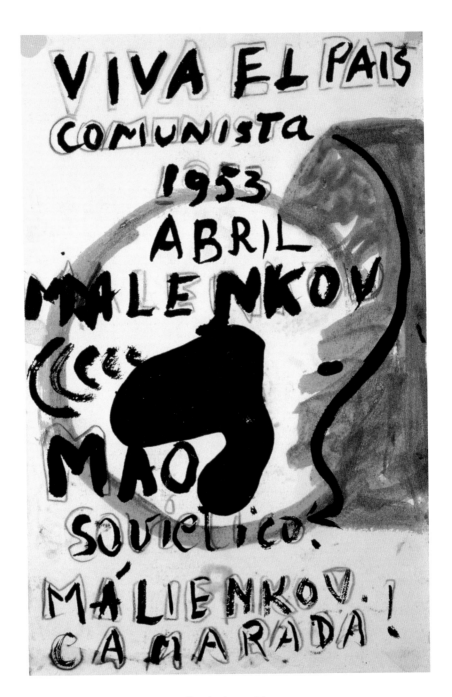

Viva el país comunista, 1953

SOCIAL CONSCIENCE

Education should be revolutionary, materialistic.

Imperialistic war is idiotic. The class struggle, even armed, is very important.

I would fight in a war.

One should fight with the strongest and with the weakest, to bring the strong one down to the level of the other, and to make the weak one stronger.

Only some laws should be always obeyed.

I have broken many social norms.

I have not regretted the things that I have done.

I have enjoyed being contradictory.

I do not believe in anyone's honesty, not even mine.

I am not socially or morally good or bad.

The best thing I have done is to be helpful in whatever way I could. One should try to help others.

In Mexico, *coraje* means "tantrum"; in Spain, "courage." It is when something does not work well. It is becoming violent when one feels offended or mistreated or when one sees an injustice.

Hitting a child or a defenseless animal is cowardice, weakness. There is no need to be cowardly. People can live in better relations with others without cowardice.

I do not believe in the efficacy of punishment and shame.

I do not know when it is justified to hit someone; [could it be] when reason fails?

I do not believe in a perfect world. But to build a better world, the Communist theory is the only one. Diego and I are Communists.

I prefer to be led because I do not know how to lead.

Self-Portrait, 1950

Los Cachuchas, c. 1927

Alejandro Gómez Arias identified the inner circle of seven friends from the group whose members singled out themselves by the berets they wore in the Escuela Nacional Preparatoria. Clockwise from top left, Gómez Arias, as the group's leader, holds a bomb in his hand because for a time he "worked with dynamite"; next to him, Miguel N. Lira holds in his hand a spinning wheel, to symbolize his support of folk art; in profile, and walking into the scene, is Octavio Bustamante, who wrote a poem based on the song "Si Adelita" from the Mexican Revolution, the words of which are written above his head; Frida Kahlo sits in the center, observing the viewer observing the group; Ángel Salas, who taught Frida how to paint a smooth surface, is playing the piano; Ruth Quintanilla is peeking into the picture at the bottom; and Carmen Jaime, seen from the back, faces the group.

FRIENDSHIP

Friendship is an alliance between people who have the same interests. It can sometimes be useful and other times completely useless.

I like having friends, a few friends.

It seems easier to have friends of the opposite sex.

With me, there cannot be a friendship between people who are also having sexual relations.

Best friends may or may not be from the same social and economic rank.

My first friends were my imaginary friend and someone in school. I do not remember anyone in particular.

Would I make sacrifices to keep someone's friendship? It depends.

I like my friends to caress me.

Between friends there should not be compliments. It is limiting.

I have never felt hatred toward any of my friends.

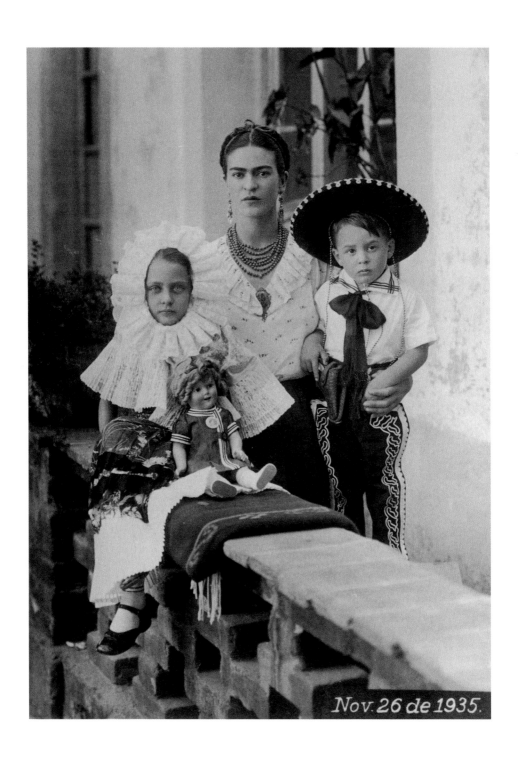

Nov. 26 de 1935.

CHILDREN

I want to have a son very much, because men defend themselves better. If I had a son, I would like him to look like Diego. If I had a girl, I would like her to look something like me, but a little better.

For my children I would like the name Diego and any name other than Frida.

The first time I wanted to have a son I was thirteen. I would see Diego walk by, and I would dream of having a son of his. I would comment on it to my little girlfriends, eating ice cream in the plaza of Coyoacán.

It is good to have children because it is normal.

I would expect nothing of my children; only that they should live more comfortably than me.

I would not want my children to help me. I would want to help them. Parents and children should not make sacrifices for one another in any way.

I would like my children to be good-looking and well endowed; most of all healthy. I would like them to be content.

I would worry constantly about their health. I especially would worry about nourishing them as children and about [feeding] their minds as they grew older.

I would not annoy my children too much.

One needs to reason with children.

I have never felt death wishes toward children.

Frida Kahlo with her niece, Isolda, and nephew, Antonio, 1935

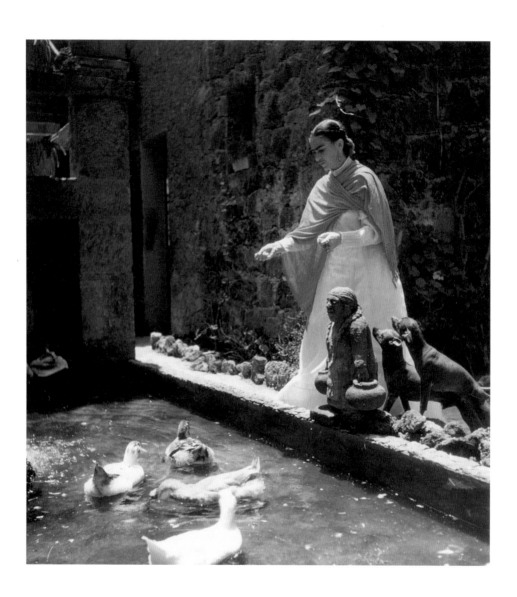

ANIMALS

As a child I played with animals. I still do.

I like touching snakes; they seem marvelous.

I used to be scared of worms and spiders. I am still disgusted by them, and by slugs.

I have seen dogs having sex, unable to separate, and puppies being born.

I have seen cows being milked. Their udders disgust me.

I do not remember my dreams of animals.

I first heard of castrating animals between the ages of nine and ten.

I have never tortured, hurt, or killed animals.

Sometimes I think we should not kill and eat animals.

I have wished for the death of only flies, fleas, and other insects.

Several times I have been bitten by dogs.

I have not been afraid of being devoured by animals.

The story of Jonah and the whale is silly.

I have never thought that animals have magical powers.

I am constantly surprised to find a resemblance between the faces of people and animals.

Frida Kahlo with her ducks and dogs, 1951

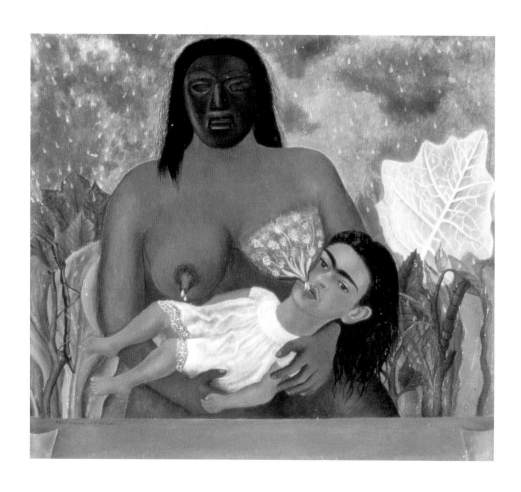

My Nurse and I, 1937

FOOD

My taste in food has changed a lot. I eat better but still not enough. Now I have a good appetite, but it has always been bad.

I remember once seeing someone breastfeeding. I do not remember my feelings about it. But if the mother and child were harmonious, I liked it; if not, it disgusted me. I was breastfed by a nanny. I do not remember how I suckled.

I am disgusted by milk. For a while I liked alcohol; now I detest it. I drink a lot of water, but more fruit juices. Food improves my health, and I have a desire to live. After eating, I feel good, but I cannot say what the ideal foods are. I prefer candy.

I eat everything, but I do not like to eat. I eat in a rush.

Still life arranged by Frida Kahlo for a picnic, 1949

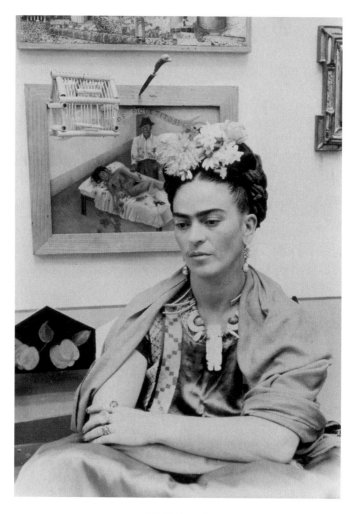

Frida Kahlo, 1948

For her exhibition in New York, in 1938, Frida Kahlo showed the painting that
is hanging on the wall behind her, which she titled *Passionately in Love* (it is also
known as *A Few Short Nips*). Although she painted and signed it in 1935, Kahlo
continued to rework the image, never quite satisfied with its emotional content,
produced in reaction to Rivera's affair with her younger sister, Cristina. In the earliest
version, Kahlo's hair was cut short and curled, just as she wore it during the time she
and Rivera were separated. The murdered woman that Kahlo depicts is essentially
nude, but Kahlo painted a shoe on the woman's right foot, her own vulnerable one.
Kahlo changed other details over the years. She swapped the original frame, made of
mirrors, for one made of plain wood, like her cross to bear. When this photograph was
taken, in 1948, the work was still unfinished. Kahlo began to stab the frame with a knife,
and would stab it many times, adding blood-like paint to suggest the event was larger
than her life. She did not stop working on the painting until she sold it.

LOVE

Love is the basis of all life.

The type of person I can fall in love with has to be very sensitive and, most of all, must attract me sexually.

I do not think I am capable of falling in love at first sight.

An average affair lasts only while it gives pleasure.

Sometimes I think about the end of the affair when it is just beginning.

I do not fall in love frequently. I remember falling in love twice.

It is right to have sex with those with whom we are in love, whoever they might be.

It is acceptable for two people who are attracted to each other to have sexual relations.

I cannot see myself in the situation of being in love without sexual gratification.

It is right to have sexual relations with someone with whom there is no relationship, even if one is not in love.

I am more afraid of being abandoned than of being disappointed.

I would react with pain and sorrow if I discovered the betrayal of the person I have chosen to love.

In general, I choose people whom I consider superior to me.

I have the defect that I like to find out all the details about the past of the person with whom I enter into an amorous relationship.

Unfortunately, I am jealous, but I think it is stupid.

Portrait of Diego Rivera, c. 1933

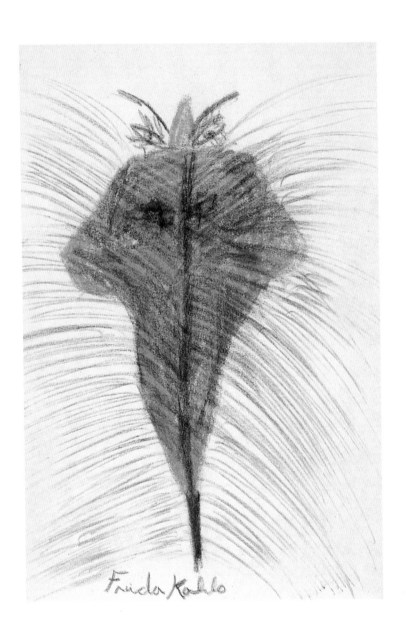

Frida Kahlo

SEX

In sex, everything that gives pleasure is good, and everything that hurts is bad.

It is good to have sex.

I masturbated for the first time between twelve and thirteen years of age, spontaneously, with my fingers on my clitoris. I was alone in bed. I do not remember what I thought about while I did it, or what happened before. I felt very good afterward. Masturbation did not hurt me. I practiced it only as a kid.

It does not bother me too much when somebody looks at my genitals.

I like the sexual parts of the opposite sex.

Breasts are aesthetic. When women's breasts are beautiful, I like them very much. But I do not like pink nipples.

During sex, my breasts play an active role. I become excited when they are touched, even by some women.

Homosexuality is very correct, very good.

I do not like sadism or masochism. In general, I think of sexual perversions as a curious thing.

I have never held back from sexual activities; only because of sickness.

I have a fear of venereal disease.

Self-Portrait as Genital, c. 1944

DEATH

I would not want to die as a hero or as a coward.

I think about death very often; too much.

I have wanted to die out of desperation. I thought of suicide in 1935 and another time a year ago [1949]. I tried it the second time. I would recommend barbiturates, to fall asleep.

The relationship between love and death is dialectic: they are opposites.

I do not believe in life after death.

It bothers me to see a cadaver.

I do not know what I would do if I were told I had one hour to live. I imagine that if I were dying I would be thinking of Diego.

The death of loved ones is the thing that terrifies me the most.

The death that moves me the most is the slow death of a young person—anyone.

Girl with Death Mask (1), c. 1938

PRODUCTIVITY

The central purpose of my life is to live.

I do not believe in destiny.

I have no ideals.

My goal in life is to do something useful in the society in which I live.

My main objective is to paint well.

I feel satisfied and happy when I have done something that I like.

I would like to organize or inspire some work, but I do not feel very capable.

I am not satisfied with the way I am.

I consider myself active but, because of illness, I am much less active than I would like to be.

My work project is to adapt my work to my health.

I would like to be more capable, to understand things and do them; to be healthier.

My productivity has depended on my sickness and my emotional state.

I do not like to influence others. I would not like to become famous.

I have done nothing deserving of acknowledgment in my life.

I have a poor level of education. I was a mediocre student.

Painting is the only skill I have—and nothing else.

Frida Kahlo's work table, 1951

NOTES

1. The true date of Kahlo's birth was July 6, 1907.
2. Short for Preparatoria, equivalent to high school, for children aged fourteen to eighteen. Kahlo attended the Escuela Nacional Preparatoria in Mexico City.
3. Kahlo's mother was actually born in 1876.
4. Kahlo actually returned in time to see her mother, but she chose not to see her in hospital or to view her body after she died.
5. In an interview with Raquel Tibol in May 1953, fourteen months prior to her death, Kahlo discussed her mother's cruelty: "Maybe she was cruel because she was not in love with my father. When I was eleven, she showed me a book bound in Russian leather where she kept the letters of her first sweetheart. On the last page she had written that the author of the letters, a young German man, had committed suicide in her presence. That man lived always in her memory. The book, bound in Russian leather, I gave to Cristi." This interview was first published as "Fragmentos para una vida de Frida Kahlo," *Novedades: México en la cultura* (March 7, 1954), p. 5. All following quotations from Kahlo are from this interview with Tibol, unless otherwise noted. All translations are the author's. I am deeply grateful to Raquel Tibol for countless generosities.
6. Kahlo's father was actually born in 1871.
7. Porfirio Díaz (1830–1915) was a soldier and president of Mexico 1877–80 and 1884–1911. His re-election in 1910 prompted the Mexican Revolution (1910–21).
8. Having been born in 1907, Kahlo was in fact three years old when the Mexican Revolution started in 1910. Led by Emiliano Zapata, the Zapatistas were an armed group, officially known as the Liberation Army of the South, who took part in the Mexican Revolution. The Villistas, or Division of the North, were led by Francisco "Pancho" Villa.
9. The nursemaid was fired for alcohol consumption. Chucho was Frida's confidant and factotum. See p. 37.
10. Kahlo recalled more specifically: "The teacher was old-fashioned, with artificial hair and very strange clothes. My first memory refers just to that teacher. She was standing at the front of a darkened room, holding in one hand a candle and in the other an orange, explaining how the universe worked—the sun, the earth, and the moon."
11. Kahlo recalled that watching her teacher's explanation had such an impact that she lost control of her bladder: "I urinated from the impression. They took off my underwear and put on me those of a girl who lived across from my house. Because of that I took such hatred to her that one day I brought her near my house and began to choke her. She already had her tongue hanging out when a passing baker took her out of my hands."
12. Kahlo refers to her half-sister Margarita, born November 7, 1898, nine years before Frida. She was Guillermo's second child with María Cardeña Espino, who died days after Margarita was born.
13. "One day my half-sister María Luisa [she means Margarita] was sitting on the potty. Playing, I pushed her and she fell backward, potty and all. Furious, she told me: 'You are not the daughter of Mamá and my papá. You were picked out of the garbage.' That comment impressed me to the point of changing me into a completely introverted child."
14. "My toys were those of a boy: skates and bicycles."
15. "I was seven when I helped my sister Matilde, who was fifteen, run away to Veracruz with her boyfriend. I opened the balcony for her and then I closed it as if nothing had happened. Matita was my mother's favorite, and her running away made Mamá hysterical. Why shouldn't Matita leave?"
16. "I would find it hateful to see how she would take mice from the cellar and drown them in a barrel. She would not leave them alone until they were completely drowned. That would impress me in a horrible way. Crying, I would say to her: 'Mother, how cruel of you!'"
17. "... it was hard to convince myself of his epilepsy. Even when, many times, carrying his camera over his shoulder and holding my hand, he would suddenly fall."
18. "I learned to assist him during his attacks on the street. I made sure that he quickly inhaled ether or alcohol, and I would keep an eye out so no one would steal his camera."

19. "Afterward I participated in the religious thing. At six, they gave me my First Communion. To prepare, Cristi and I attended instruction for a year, but we would escape and go to eat fruit—*tejocotes, membrillos,* and *capulines*—in a nearby garden."

20. "My mother was for me an enormous woman, but religion never brought us together. My mother arrived at history through religion. We had to pray before meals. While the others were concentrating, Cristi and I would look at each other, trying to keep from laughing."

21. Kahlo wrote to Eduardo Morillo Safa, her main patron, that she planned to do a painting of this memory: "It also seems to me a good idea to paint the hairless shawled woman ..." Letter from Frida Kahlo to Eduardo Morillo Safa, dated October 11, 1946, in the collection of Mariana Morillo.

22. "At six, I had poliomyelitis. Since then, I remember everything clearly. I spent nine months in bed. It all began with a horrible pain in my right leg, from the thigh down. They would wash my leg in a small basin with walnut water and warm compresses. The leg became very thin. At seven, I wore [polio] booties. At first, I suppose, the mocking did not phase me, but afterward it did, and each time more intensely."

23. Kahlo told Raquel Tibol that her imaginary friendship developed as a reaction to being told she was not the child of her parents: "Since then, I have enjoyed adventures with an imaginary friend."

24. Kahlo painted this childhood memory in *They Ask for Planes and Get Straw Wings* (1938). Bertram Wolfe also wrote about it: "Remembering the time when her parents dressed her as an angel (wings that caused a great unhappiness because they would not fly) ..." Bertram Wolfe, "Rise of Another Rivera," *Vogue,* November 1, 1938, p. 131.

25. Guillermo Kahlo's father had been a jeweler. When Guillermo arrived in Mexico, he joined the Diener brothers in their family business, La Perla, which became Mexico's most prestigious jewelry store. There, Kahlo met Matilde Calderón, who became his second wife. After he left the store to work as

a photographer (a trade he had learned from his father-in-law), Guillermo leased office space from the Dieners and set up his studio.

26. Kahlo is referring to the amphitheater at the Escuela Nacional Preparatoria, where Rivera was painting *La creación* (1922–23).

27. Pico was the nickname given to Rivera and Lupe Marín's oldest daughter, Guadalupe. She received her nickname "because she resembled a little mouse, her head was pointed, and her legs were very weak," and because she was "a little bit extra" of her mother. See Loló de la Torriente, *Memoria y razón de Diego Rivera* (Mexico City: Editorial Renacimiento, 1959), II, p. 253.

28. On September 17, 1925, Kahlo and Gómez Arias were involved in a bus accident. Kahlo was left with multiple injuries; Gómez Arias recovered well. While Kahlo was hospitalized, he went to Europe. When he returned, he brought Kahlo her first art books.

29. The drawing to which Kahlo refers is dated 1927 and is documented in Helga Prignitz-Poda, Salomon Grimberg, and Andrea Kettenmann (eds.), *Frida Kahlo: Das Gesamtwerk* (Frankfurt am Main: Neue Kritik, 1988), no. 179. Henceforth, Prignitz-Poda *et al.* 1988. See p. 74, top drawing.

30. Kahlo is referring to *Self-Portrait with Velvet Dress* (1926), now in a private collection; Prignitz-Poda *et al.* 1988, no. 2.

31. This portrait, dated December 1926, is now lost; Prignitz-Poda *et al.* 1988, no. 5.

32. *Portrait of Miguel N. Lira* (1927) is now in the Instituto Tlaxcalteca de la Cultura, Museo de Arte de Tlaxcala, Mexico; Prignitz-Poda *et al.* 1988, no. 7.

33. Galant was a friend from Coyoacán. *Portrait of Alicia Galant* (1927) is now in the Museo Dolores Olmedo, Xochimilco, Mexico City; Prignitz-Poda *et al.* 1988, no. 8.

34. This portrait is now in the Museo Frida Kahlo, Coyoacán, Mexico City; Prignitz-Poda *et al.* 1988, no. 13.

35. This painting, the only unidentified portrait of a woman in Kahlo's collection, may be Prignitz-Poda *et al.* 1988, no. 27.

36. This is a drawing, not a painting, and is now in the Museo Dolores Olmedo. The sitter is actually a friend from the German school called Ady Weber, not a cousin; Prignitz-Poda *et al.* 1988, no. 183.
37. This drawing, undocumented until now, is in a private collection.
38. Kahlo is referring to the painting *Frida and the Cesarean* (1929), now in the Museo Frida Kahlo. It was previously believed to have been painted in 1932; Prignitz-Poda *et al.* 1988, no. 36.
39. Salvadora and Herminia worked in the Riveras' household. Kahlo sold her first painting to Jackson Phillips, an American industrialist, who, on a visit to Mexico, also bought an encaustic portrait of Lupe Marín by Rivera. Prignitz-Poda *et al.* 1988, no. 14.
40. Kahlo is referring to *Self-Portrait, Time Flies* (1929), now in a private collection in the United States; Prignitz-Poda *et al.* 1988, no. 20.
41. Kahlo is probably referring to *[Portrait of Salomon] Hale's Sister* (1930); Prignitz-Poda *et al.* 1988, no. 26.
42. *Portrait of Lupe Marín* (1929) is a painting of Rivera's second wife. It was cut up with scissors by Marín; Prignitz-Poda *et al.* 1988, no. 22.
43. This portrait is lost and has never before been documented.
44. Kahlo is referring to *Self-Portrait* (1930), now in a private collection in the United States; Prignitz-Poda *et al.* 1988, no. 25.
45. This painting was lost and, until recently, undocumented. Alejandro Gómez Arias did not mention it when we worked on *Das Gesamtwerk* (Prignitz-Poda *et al.* 1988), but it was found among his belongings by his heirs after his death and is now in a private collection in Mexico.
46. Kahlo is referring to *Frieda and Diego Rivera* (1931); Prignitz-Poda *et al.* 1988, no. 29.
47. Jean Wight was the lover of Dr. Leo Eloesser, Kahlo's physician. *Portrait of Jean Wight* (1931) is now in a private collection in the United States; Prignitz-Poda *et al.* 1988, no. 28.
48. This woman was Eva Frederick. Kahlo did one portrait of her in oil and one drawing; Prignitz-Poda *et al.* 1988, nos. 31 and 188 respectively. Eva

Frederick, known as Maudell, also posed for Manuel Álvarez Bravo, Lola Álvarez Bravo, and Edward Weston, among others.
49. Kahlo is referring to the first wife of Lord Francis John Clarence Westenra Plantagenet Hastings (Lord John Hastings), who was a student of Rivera's when he was painting the murals for the Detroit Institute of Arts. *Portrait of Lady Cristina (Casati) Hastings* (1931) is now in the Museo Dolores Olmedo; Prignitz-Poda *et al.* 1988, no. 189.
50. Kahlo is referring to *Window Display in Detroit* (1932), now in a private collection; Prignitz-Poda *et al.* 1988, no. 33.
51. Kahlo is referring to *Henry Ford Hospital* (1932), now in the Museo Dolores Olmedo; Prignitz-Poda *et al.* 1988, no. 35.
52. Kahlo is referring to *Self-Portrait on the Borderline* (1932), now in the collection of Carmen Reyero; Prignitz-Poda *et al.* 1988, no. 34.
53. Kahlo is referring to Rivera's murals (1933) for the Rockefeller Center in New York. When Rivera included a portrait of Lenin, his mural was removed. See Hayden Herrera, *Frida: A Biography of Frida Kahlo* (New York: Harper & Row, 1983), pp. 164–68. For a comprehensive record of the event, see Irene Herner de Larrea, *Diego Rivera: Paradise Lost at Rockefeller Center* (Mexico City: EDICUPES, 1987).
54. Kahlo is referring to *Self-Portrait with Necklace* (1933), now in El Museo del Barrio, New York; Prignitz-Poda *et al.* 1988, no. 38.
55. Kahlo is referring to *Portrait of Diego Rivera* (1934), now in the Jacques and Natasha Gelman Collection of Modern and Contemporary Mexican Art. It was previously believed to have been painted in 1937; Prignitz-Poda *et al.* 1988, no. 45.
56. This painting is lost. It was previously believed to have been painted in 1938; Prignitz-Poda *et al.* 1988, no. 53.
57. Kahlo is referring to the self-portrait *Me and My Doll* (1937), now in the Jacques and Natasha Gelman Collection of Modern and Contemporary Mexican Art; Prignitz-Poda *et al.* 1988, no. 50.

58. This painting is lost and has never before been documented.

59. This painting is lost and has never before been documented.

60. It is unclear which portrait Kahlo is referring to here. When Dolores del Río died, she had two paintings by Kahlo in her collection: *Earth Itself (Two Nudes in a Forest)* (1939) and *She Plays Alone (Girl with Death Mask)* (1938); Prignitz-Poda *et al.* 1988, nos. 69 and 65 respectively. It seems feasible that in *Earth Itself*, originally a detail from Kahlo's *What the Water Gave Me* (c. 1934; p. 56), the woman lying down is Dolores del Río, so this may be the portrait to which Kahlo is referring.

61. This portrait is lost and has never before been documented.

62. The two paintings that belonged to Mary Sklar are *Fulang-Chang and I* (1937), now in the Museum of Modern Art, New York, and *Tunas* (1937), now in a private collection; Prignitz-Poda *et al.* 1988, nos. 52 and 55 respectively.

63. Anson Conger Goodyear was president of the Museum of Modern Art, New York, from 1929 to 1939. He commissioned *Self-Portrait with Monkey* (1938) after seeing *Fulang-Chang and I* at the Julien Levy Gallery in New York. He eventually donated the painting to the Albright-Knox Art Gallery, Buffalo; Prignitz-Poda *et al.* 1988, no. 61.

64. Kahlo is referring to *Self-Portrait with Cropped Hair* (1940); Prignitz-Poda *et al.* 1988, no. 72.

65. Correspondence between Helga Prignitz-Poda and the Pushkin Museum reveals that the painting is not there. The other museum of painting in Moscow, the Tretyakov Gallery, contains only Russian works. I thank Laura Hoover, who, while living in Russia, also searched for the painting in both museums at my request, without success.

66. This painting is documented as *Without Hope* (1945), now in the Museo Dolores Olmedo; Prignitz-Poda *et al.* 1988, no. 110.

67. Inés Amor owned a gallery in Mexico City. This painting is now in a private collection in Chicago; Prignitz-Poda *et al.* 1988, no. 112.

68. This painting is now in a private collection in Chicago; Prignitz-Poda *et al.* 1988, no. 113.

69. Kahlo is referring to *Diego and I* (1949), now in a private collection; Prignitz-Poda *et al.* 1988, no. 119.

70. Kahlo is referring to *The Love Embrace of the Universe, the Earth, Mexico and Señor Xólotl* (1949), now in the Jacques and Natasha Gelman Collection of Modern and Contemporary Mexican Art; Prignitz-Poda *et al.* 1988, no. 118.

71. Gómez, a hydraulic and agronomic engineer, was a close friend and patron of Rivera's. *Portrait of Ing. Marte R. Gómez* (1944) belongs to the Autonomous University of Chapingo, where Gómez studied when it was the Escuela Nacional de Agricultura; Prignitz-Poda *et al.* 1988, no. 98.

72. In 1944, Kahlo painted several family members: *Portrait of Ing. Eduardo Morillo Safa*, now in the Museo Dolores Olmedo; *Portrait of Mariana Morillo*, now in a private collection in the United States; *Portrait of Doña Rosita Morillo*, now in the Museo Dolores Olmedo; *Portrait of Alicia Morillo Safa and Her Son Eduardo* (unfinished), now in the Museo Frida Kahlo; and *Portrait of Lupita Morillo*, now in a private collection; Prignitz-Poda *et al.* 1988, nos. 95, 96, 97, 99, and 144 respectively.

73. This painting is now in the Museo Dolores Olmedo; Prignitz-Poda *et al.* 1988, no. 92.

74. This still-life painting was probably acquired by Helena Rubinstein during her trip to Mexico in December 1941. At the time of her death, it did not appear in Rubinstein's estate inventory, nor was it donated with the Rubinstein collection to the state of Israel, nor was it inherited by any of her heirs. The Helena Rubinstein Foundation has no documentation of it ever being lent from her collection.

75. This painting is now in a private collection; Prignitz-Poda *et al.* 1988, no. 83.

76. This painting is now in a private collection in Houston, Texas; Prignitz-Poda *et al.* 1988, no. 109.

Part Object, c. 1947

FRIDA KAHLO'S
MEDICAL HISTORY

HENRIETTE BEGUN

Translated by Salomon Grimberg from the original Spanish

Little is known about Henriette Begun, a German obstetrician–gynecologist living in Mexico. She gathered the material for this clinical history in 1946, eight years before Kahlo's death. Kahlo provided most of the information, including the incorrect date of birth (July 7, 1910), which she used throughout her life; her actual date of birth was July 6, 1907. Other facts presented here may also conflict with subsequent accounts. The clinical history was first published in Mexico by Raquel Tibol in her book Frida Kahlo: una vida abierta *(1983). A copy of it is in the archives of the Centro Nacional de Investigación, Documentación e Información de Artes Plásticas (CENIDIAP), Mexico City.*

Family Medical History

Frida Kahlo: Birth, July 7, 1910. Parents deceased; father German, mother Mexican.

Father: Epileptic seizures since age nineteen, apparently caused by a fall. Died at seventy-four from a heart attack. [Guillermo Kahlo actually died at age sixty-nine.] One year before his death, he was diagnosed with bladder cancer but diagnosis was unconfirmed.

Mother: Apparently healthy. Five children, one died at birth. Menopause at forty-five(?). Thereafter, suffered from similar seizures to her husband. Died at fifty-nine during gallbladder operation. [Matilde Calderón actually died at age fifty-six.] Half a year earlier, diagnosed with breast cancer.

Maternal grandmother: Cancer in one eye; died of intestinal occlusion in old age.

Paternal grandfather: Died of pulmonary tuberculosis.

Paternal uncle: Died of galloping tuberculosis.

Maternal uncle: Died at forty-three from hepatic tuberculosis.

Two half-sisters [from her father]: Both total hysterectomy; one from uterine cancer and second because of cysts.

Oldest sister: Total hysterectomy owing to cysts; sterility; cardiac lesion.

Second sister: Oophorectomy because of cysts; ovarian insufficiency; three spontaneous abortions at three-and-a-half months of pregnancy.

Third sibling [only brother]: Died of pneumonia a few days after birth.

Youngest sister: Two normal, healthy children (only sister whose deliveries were normal). Cyst removed at twenty-nine, as well as part of pancreas (Dr. Gustavo Baz).

Personal Medical History

1910–17: Normal birth. During this time (childhood), measles, chicken pox, frequent tonsillitis; normal development and weight.

1918: Trauma to right foot from tree trunk; thereafter, light atrophy of right leg with light shortening and leaning to right of foot. Some physicians diagnose poliomyelitis, others "white tumor." Treatment: sunbaths and calcium. However, during this time, patient continues normal life, sports *etc.*; normal mental state. No pain or discomfort.

1925: Menarche.

1926: Accident causing fracture of lumbar vertebrae 3 and 4; three pelvic fractures; 11(?) [fractures] of right foot; dislocation of left elbow joint; penetrating wound by steel bar entering through left hip and exiting through vagina, tearing left labia; acute peritonitis; cystitis with canalization for several days. Bedridden in Red Cross Hospital for three months. Fracture of [spinal] column goes unnoticed by physicians until she is

cared for by Dr. Ortiz Tirado, who orders immobilization with plaster corset for nine months. Three or four months after wearing corset, patient suddenly feels whole right side to be "asleep" for an hour or longer. Phenomenon diminished with shots and massage, and does not return. When plaster corset is removed, she reinitiates "normal" life, but has "continuous sense of tiredness," and pain in the spine and right leg. [Kahlo's accident actually took place in 1925.]

1929: Marriage. Normal sex life; becomes pregnant during first year. Abortion performed by Dr. J. de Jesús Marín owing to poor pelvic formation. Wasserman and Kahn tests [for syphilis]: negative. Constant tiredness continues.

1931: Examined by Dr. Leo Eloesser in San Francisco; various laboratory tests performed, Wasserman and Kahn among them: results slightly positive. Restarts treatment with Neomycin for two months but does not finish it. At this time, pain in right foot increases, atrophy of right leg up to thigh increases considerably, right foot tendons retract; much difficulty walking normally. Dr. Leo Eloesser diagnoses congenital malformation of [spinal] column, leaving as secondary the effects of the accident. X-rays suggest considerable scoliosis with apparent fusion of lumbar vertebrae 3 and 4 and disappearance of intervertebral meniscus [cushion]. Analysis of spinal fluid: negative. Wasserman and Kahn: negative. Koch investigation [for tuberculosis]: negative. As always, strain on spinal column continues. Small trophic ulcer [caused by impaired blood microcirculation] appears on right foot.

1932: In Detroit, Michigan, attended by Dr. Pratt from Henry Ford Hospital for second pregnancy [four months], having suffered a spontaneous abortion, despite rest and various treatments. Wasserman and Kahn tests repeated: negative. From spinal fluid: negative results for infection. Trophic ulcer continues despite treatments.

1934: Third pregnancy. Dr. Zollinger in Mexico carries out abortion in third month. Exploratory laparotomy [of abdominal cavity]: ovarian infantilism; appendectomy. First operation on right foot; removal of five phalanges. Very slow healing.

1935: Second operation on right foot, finding several sesamoids [small bony nodules in thickness of tendons caused by tension, compression, and wear and tear]. Healing, equally slow; nearly six months.

1936: Third operation on right foot: removal of sesamoids to alleviate pain; also a peri-arterial sympathectomy to increase blood flow to foot. Healing again slow. Trophic ulcer persists. Thereafter, nervousness, lack of appetite, and strain of [spinal] column, alternating with periods of improvement.

1938: In New York, sees specialists in bones, nervousness, and skin, and continues in same state until she sees Dr. Glusker, who is able to close trophic ulcer with electrical and other treatments. On sole of foot, calluses are formed on support areas. Wasserman and Kahn tests: negative.

1939: Paris, France. Renal E. coli infection with high fevers. In despair, drinks large amounts of alcohol (nearly one bottle of cognac a day). At end of year, has very intense pain in vertebral column. Attended in Mexico by Dr. [Juan] Farill; has absolute bed rest, with weight traction of 20 kilograms on spinal column. Several independent specialists recommend Albee Operation; Dr. [Fred Houdlett] Albee suggests same by letter. Opposed to this surgery are doctors Federico Marín and Eloesser. Fungus infection appears on right-hand fingers.

1940: Moves to San Francisco, California. Treated by Dr. Leo Eloesser: absolute rest, intensive feeding, prohibition of alcoholic beverages, electrotherapy, and calcium therapy. Second lumbar puncture with lipiodol [radiopaque contrast] for X-ray examination: negative results. Recovers to an extent and returns to more-or-less normal life.

1941: Feels exhausted again with strain on back and violent pains in extremities; weight loss, asthenia [chronic fatigue], and irregular menstruation. Sees Dr. Carbajosa; initiates hormonal treatment that greatly helps regulate menstruation and heal skin infection on fingers of right hand.

1944: Tiredness definitely increasing, as well as pain in [spinal] column and right foot. Dr. Velasco Zimbrón visits her and orders total rest and steel corset; initially she feels more comfortable while wearing corset, although pains do not disappear. When she removes corset, she feels "lack of support," as if she cannot hold herself up. Lack of appetite continues, with rapid loss of weight: 6 kilograms in six months. Feels weakness and dizziness and is forced to stay in bed with low-grade fever (37.5–37.9°C) in the evening. Several physicians are consulted. Dr. Carbajosa and Dr. Gamboa are inclined to diagnose tuberculosis. They suggest repeating lumbar puncture to aid diagnosis, with absolute rest and intensive feeding. Visited by Dr. Ramírez Moreno; he leans toward a diagnosis of syphilis, initiating treatment with blood transfusions (eight, each 200 cubic centimeters), sunbaths, and intensive feeding. State of patient continues to worsen. Receives bismuth treatment but continues to deteriorate. Dr. Carbajosa insists on tuberculosis treatment. After consultation with Dr. Cosio Villegas, the clinical picture seems to confirm the diagnosis made by Dr. Carbajosa. Treatment: absolute rest, methyl antigen, calcium, and intensive feeding. Dr. Zimbrón repeats laboratory tests and X-rays, and carries out lumbar puncture with introduction of lipiodol (third time). Inoculation of mice to confirm diagnosis: negative results. Visit by Dr. Gea González, whose opinion is that syphilis and tuberculosis are coexisting. He requests eye examination to check for ocular inflammation [a symptom of syphilis], and initiates treatment with arsenicals and general treatment for tuberculosis. Dr. Velasco Zimbrón takes new X-rays and concludes that patient needs to have laminectomy to relieve pressure on spinal cord by treating narrowing of spinal canal, and [bone] graft in [spinal] column (Albee Operation). Result of eye examination is hipoplasia papillary [a probable defective configuration of the optic disc or underdevelopment of optic nerve]. She is not operated on.

1945: For the first time, her right shoe is raised (2 centimeters) to regulate shortening of right leg. Again, she is placed in plaster corset (by Dr. Zimbrón) but cannot tolerate it for more than a few days because of intense pain in [spinal] column and leg. Lipiodol, which was injected in all three lumbar punctures, has not been eliminated, provoking increase in intracranial pressure, causing continuous pain in nape of neck and [spinal] column. General deafness, growing stronger during nervous excitation. General state: exhausted.

1946: Visited by Dr. Glusker. Advised to go to New York to see Dr. Philip Wilson, surgeon and specialist in operations of the [spinal] column. Leaves for New York in May. Examined carefully by Dr. Wilson and by nerve specialist *etc.* Their opinion is that a spinal fusion is urgent and necessary. It is carried out by Dr. Wilson in June. Four lumbar vertebrae fused with the application of pelvic graft held by 15-centimeter Vitallium plate. Patient remains in bed for three months and recovers from surgery. Advised to wear steel corset for eight months and to live quietly and restfully. In first three months after surgery, real improvement is apparent. Then patient is unable to follow Dr. Wilson's instructions, carrying on a life with much nervous excitation and little rest, and does not convalesce as expected. Begins to feel same tiredness as before, with pain in the nape and [spinal] column, lack of energy, and weight loss. Macrocytic anemia [caused most commonly by vitamin B-12 deficiency]. Fungus infection reappears on right-hand fingers. Very bad nervous agitation and great depression.

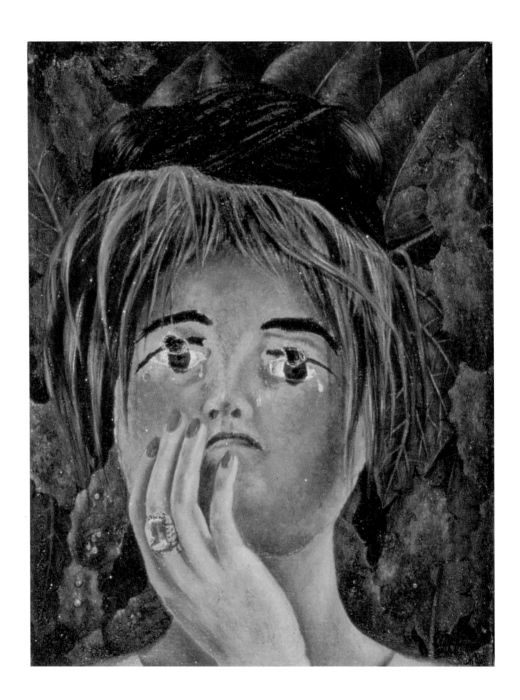

The Mask, 1945

PSYCHOLOGICAL ASSESSMENT
OF
FRIDA KAHLO

JAMES BRIDGER HARRIS

Introduction

Psychological testing is used to understand how individuals experience life, themselves, and others. People may be understood through the art they produce or by descriptions from friends and family, by observation, or through their dreams. Psychological testing is unique because of its systematic method, making it easier to compare individuals. For example, each person who undertakes the Rorschach Inkblot Test responds to the same ten cards in the same order. Integrating an individual's life history with psychological testing is a powerful method for revealing motivations, even motivations of which he or she may be unaware.

Nevertheless, even with the advantage of psychological testing, understanding the individual is a daunting task that requires both scientific and creative ways of knowing. The clinical standard is to utilize both. For example, a woman who has just lost her mother in a car wreck might respond to an inkblot, "This looks like lost sheep trying desperately to find food." The response can be understood by scoring the content, such as animals and food, against a particular scale, and by comparing the subject's test scores to a group of scores. This may reveal a significantly elevated depression scale. One could also approach the response by directing attention to the subject's self-concept and view of environment. In this case, the woman's emotional reaction to loss is inherent in the theme of lost sheep desperate for nurture.

Projective tests, the type that Olga Campos administered to Frida Kahlo, are highly valued for their combination of scientific and creative approaches to understanding. Projective tests require the individual spontaneously to structure unstructured material, thereby revealing the structuring principle underlying his or her personality. These tests assess self-concept, attitudes toward significant others, perceptions of the environment, major concerns, and significant conflicts. Projective tests can also shed light on unconscious conflicts and internalized experience. A powerful component of the assessment of Kahlo is the outcome of the four tests spread over more than a year. By combining the tests—that is, by looking at the common themes among them—a clear picture emerges. The writing of this report varies from the standard format of providing explanation and diagnostic formulation. While these features are included, the reader is also provided with a wealth of raw data, and is invited, if not compelled,

to integrate the four tests with Kahlo's life history and develop a psychological understanding of her.

Frida Kahlo's psychological testing was undertaken by Olga Campos as part of research for a book on the creative process of artistic individuals. Publication of Kahlo's psychological assessment based on psychological testing is unprecedented. No one else of international stature in the art world has ever exposed so much. How ironic that "the great concealer," as Kahlo referred to herself, is now, through psychological testing, a "great revealer."

Campos administered the following four tests, which I have interpreted in the psychological assessment that follows:

Rorschach Inkblot Test:
This test consists of ten cards showing inkblots of varying designs and colors. The individual is asked to describe what she sees on each card. Because of the highly ambiguous nature of inkblots, the Rorschach Test is considered the prototypical projective test. Since inkblots are indeterminate, or liable to more than one interpretation, the individual "projects" her personality by organizing the inkblot in her own unique way. The individual's associations can be followed not only by the context and structure of her response, but also by the contiguity of one response with another. I scored Kahlo's Rorschach using Exner's Comprehensive System.[1] This system was not yet developed when Kahlo was tested, but it is the system most widely used today in the United States, and is credited by many with "saving" the Rorschach Inkblot Test from an early dismissal owing to lack of "objective" data.

Thematic Apperception Test (TAT):
The material consists of nineteen black-and-white pictures, mostly of people in scenes or situations, and one blank card. The subject is asked to make up a story about each picture. Each card has a certain "psychological pull." For example, a picture of a girl and a woman seated on a couch pulls for issues regarding mother–daughter relations. The blank card is the ultimate projective test because, since it provides no stimulus other

than a blank space, the person being tested is able to project complete subjectivity. The premise of this test is the tendency of people to interpret an ambiguous human situation in conformity with their past experiences and present needs, thus revealing some of a person's dominant drives, emotions, complexes, and conflicts.[2]

Bleuler–Jung (Word Association) Test:
The subject is asked to say the first two words that come to mind after the examiner reads a stimulus word. The process of saying the first thing that comes to mind is called "free association" and often reveals significant attitudes or feelings toward the stimulus word. Some words appear more highly emotionally charged than others; for example, "death" seems more charged than "water." This test was initially developed to tap the Jungian notion of the collective unconscious. It was used in Kahlo's assessment, however, to underscore certain feelings and attitudes toward a variety of people and issues.

Szondi Test:
This test is composed of six sets of pictures, with eight pictures, each featuring the face of a mental patient, in each set. The subject is asked to identify the two most-liked and the two least-liked faces from each set. This yields the twelve most-liked and twelve least-liked pictures. The process of looking at each set of pictures and identifying the two most-liked and two least-liked faces is repeated for a total of ten times, generally spread out over a course of days. This then yields a grand total of 120 most-liked and 120 least-liked pictures. The number of times that a particular face is picked is calculated, and inferences are then made about the subject's personality. Leopold Szondi, the creator of the test, believed in a theory of genotropism, or that specific genes regulate mate selection. This then forms the genetic unconscious, separate and distinct from the Freudian unconscious and the collective unconscious (of Jung). The results of Szondi's test classified a person into four basic categories: homosexual/sadistic, epileptic/hysterical, catatonic/paranoid, and depressive/manic.[3]

The theoretical underpinnings of the Szondi test have come into such serious question that the test is no longer in wide acceptance, and the calculations are not used in this assessment. However, Kahlo associated to (talked freely about) the last two

most-liked and last two least-liked faces she selected; only these associations are used in the current assessment.

The emotional state of the person at the time of testing is meaningful. Psychological tests assess both the state (that is, the current condition) of the person being evaluated, as well as the person's traits (enduring personality characteristics). Thus, understanding what is going on in the person's life at the time of the evaluation is crucial to the test's interpretation.

THE PSYCHOLOGICAL ASSESSMENT

Name:	Frida Kahlo
Age:	42 years old
Date of Birth:	July 6, 1907
Dates of Assessment:	7/5/1949; 9/11, 12/1949; 9/9, 11, 12, 20, 22, 27, 28/1950; 10/8, 27/1950
Examiner:	Olga Campos
Assessment Author:	James B. Harris, Psy.D.
Techniques Administered:	Clinical Interview Rorschach Inkblot Test (7/5/49) Thematic Apperception Test (TAT) (9/11, 12/49) Bleuler–Jung (Word Association) Test (9/20/50) Szondi Test (9/12/50)

Background Information

Frida Kahlo's psychological testing was initiated by Olga Campos in order to explore and understand the psychology of creativity. No other artist of Kahlo's stature has been courageous enough to make herself as vulnerable. Kahlo laid herself bare in both the psychological testing and the extensive clinical interview.

The Rorschach, administered in Kahlo's home on July 5, 1949, was the first of the tests for the assessment. Two weeks later, on July 17, Diego Rivera, Kahlo's husband,

House on Fire, c. 1947

begged her for a divorce so he could marry Emma Hurtado, a long-time lover who kept his life, as well as his business dealings, organized—something Kahlo, owing to chronic illness, could no longer do. Rivera had had numerous affairs and had just ended a liaison with the film star María Félix at the end of June or early July 1949. At one point, Rivera and Félix had approached Kahlo requesting that she give him a divorce. Kahlo, assuming they were joking, agreed until she realized they were serious, then panicked. Frida's sister Cristina, out of concern for Kahlo, was instrumental in persuading Félix to end the relationship with Rivera. Shortly thereafter, Kahlo attempted suicide with an overdose of barbiturates when she received Rivera's legal written request for a divorce so he could marry Hurtado. On the document she wrote: "Today, 17 of July of 1949, head of a dead bird, I will not paint again, nor walk, I want to die, I want to die."

Kahlo was admitted to the American British Cowdray Hospital in Mexico City in early 1950 for unclear reasons, and it was rumored that she did not have long to live. This hospitalization lasted off and on into 1951. The three other psychological tests were administered at her bedside between seven back surgeries, the indirect result of a bus accident twenty-six years earlier, when Kahlo was eighteen years old, in which she suffered multiple fractures in her right foot and leg, pelvis, spinal column, and left arm. In the same accident, she was impaled by a steel rod that entered her back and emerged through the side of her vagina, tearing the labia.

Kahlo's history, however, indicates that she already felt physically and emotionally impaired by the time of the bus accident. For example, she suffered from polio between the ages of six and seven. As a child, she developed coping

July 17, 1949

strategies in an attempt to mask the results of polio: she skipped to cover her limp, and wore thick socks to disguise the thinness of her right leg. Her early childhood memories are replete with allusions to being unwanted, alienated, deformed, different, strange, and ugly—a misfit. Other children referred to her as "Frida the gimp" or "Frida peg-leg." The memory of a teacher wanting to conceal her thinner leg with a long skirt during a school play remained with Kahlo all her life.

At various times throughout Kahlo's medical history, physicians considered the possibility of an infection with syphilis or tuberculosis. At one point, it was believed she may have been suffering from both. If this was so, either disease may have accounted for some of her mood disturbances. Kahlo reported having had two abortions and one miscarriage. The first abortion was in 1929, after three months of pregnancy. The miscarriage that occurred in 1932 followed a failed attempt to abort with quinine. The second abortion took place in 1934, the year in which she and Rivera separated after her discovery of his affair with her sister Cristina. During that year, Kahlo was romantically involved with the Japanese-American sculptor Isamu Noguchi, and it is feasible that the aborted child could have been his. Kahlo had a history of intermittent consumption of significant amounts of alcohol, sometimes drinking nearly a full bottle of brandy each day, in an apparent attempt to deal with chronic pain. At the time of Campos's assessment, Kahlo reported having discontinued drinking since 1947. Finally, her medical condition appears to have been further complicated by extensive use of Demerol for pain and Seconal to help her sleep, medications to which she appears to have been addicted at various times.

Kahlo's undergraduate school education at the Escuela Nacional Preparatoria in Mexico City was interrupted and never completed because of the bus accident. Until then, she had planned to study medicine and become a histology medical illustrator.

In the decade preceding the testing Kahlo had achieved professional success. In 1938, her husband arranged her first major sale of paintings, to Edward G. Robinson. In November of that year, she held a one-woman show at Julien Levy's gallery of Surrealist art in New York, receiving favorable reviews. From New York she traveled to Paris, where her work was exhibited in the prestigious Galerie Renou et Colle. In 1943, Kahlo was appointed to a teaching position at the Ministerio de Educación Pública's

painting and sculpture school, though her teaching schedule was reduced in 1944 because of poor health and increased pain.

Kahlo married Diego Rivera for the first time in 1929. It was her first marriage and his third. They divorced ten-and-a-half years later, only to remarry within a year, in 1940. Their relationship was stormy. Both had numerous affairs, and Rivera was open about his. Though no longer involved with María Félix during Kahlo's psychological evaluation, he remained involved with a permanent lover–companion, his agent Emma Hurtado, whom he married shortly after Kahlo's death. Resentfully, Kahlo nicknamed Hurtado *la hurtadora*, meaning "the thief." Kahlo hid her affairs with men from Rivera but was more comfortably open about her affairs with women, which Rivera found acceptable and amusing.

Frida Kahlo's mother, Matilde Calderón, died in 1932, seventeen years before the testing, after a complicated surgical intervention in which she had 160 gallstones removed. She was already suffering from breast cancer. Kahlo's father, Wilhelm Kahlo, died at age sixty-nine, eight years before the testing, of a heart attack. When Wilhelm Kahlo had emigrated to Mexico from Germany in 1891, he changed his name to Guillermo, married María Cardeña Espino, and had two daughters with her: María Luisa and Margarita. María Cardeña Espino died following the birth of Margarita.

Matilde Calderón was twenty-four years old when she met Guillermo, who was five years older. Both were working for La Perla, Mexico's most prestigious jewelry firm. Following Guillermo's marriage to Matilde, both daughters from his first marriage were placed in a convent at Matilde's request. Guillermo and Matilde had five children together: Matilde, Adriana, a son who died in infancy, Frida, and Cristina. Only eleven months separated the births of Frida and Cristina. Matilde was unable to nurse Frida. Frida's first wet-nurse was fired for consuming alcohol; then Frida was cared for by Hilaria, an Indian wet-nurse.

Guillermo Kahlo eventually gave up working at the jewelry store, and supported the family with his photography, which he had learned from his father-in-law. However, there were hard times financially for the family, and these included mortgaging their home and selling their French furniture. Of all the daughters, Frida was the closest to her father. She was the only one of his children to be given a German name (which,

in her adult years, she changed from the original German spelling, Frieda), and the only one sent to German school.

Behavioral Observations

Kahlo's appearance during testing was consistent with her age of forty-two years. She had intense, dark eyes and dyed black hair neatly combed and arranged. Dressed in a Tehuana costume—a brightly colored Mexican dress—she wore carefully applied makeup. Though cooperative in her assessment, she was skeptical and frequently humorous. Her speech was clear and coherent. Her thoughts were goal-directed, and her thought content focused on the artistic merit of the tests and on self-deprecation. She denied currently thinking about suicide. In addition to her overdose, clinical signs of depression appeared prior to her hospitalization in the form of despondency, lack of interest in routine activities, and diminished appetite and weight loss.

Test Results

Kahlo's personality testing suggests a serious mood disturbance in the form of a chronic, low-grade depression and periodic overlays of major depression. Testing and history indicate her bouts of major depression were severe, including debilitating unhappiness, suicidal thoughts, chronic fatigue, and days spent unable to get out of bed. This condition was compounded by what is known as chronic pain syndrome. This syndrome involves intractable physical pain, leading to periods of social withdrawal, bed rest, chemical dependency, depression, decreased ability to work, and severe strain on social and family support systems. At times, of course, Kahlo became profoundly depressed and gave up. Her Depression Index, a statistically based measure of depression based on her Rorschach Test, is significantly elevated. This means her personality organization was prone to frequent disturbances of mood. Emotional modulation problems existed wherein she was overly intense and impulsive in her emotional displays. Negative, painful emotions would dominate her experiences and pervasively influence her thinking.

In addition to difficulty in regulating mood, Kahlo had difficulty integrating and maintaining a cohesive sense of self. Her personality features suggested a narcissistic nature: self-centered, self-dramatizing, self-absorbed, and with profound self-esteem issues. A central psychic conflict is seen between a haughty grandiosity and concomitant feelings of inferiority. This conflict, deeply painful and intense, was exacerbated excruciatingly by Rivera's affair with María Félix and his ongoing relationship with Emma Hurtado, because Kahlo relied primarily on Rivera to assist in regulating her self-esteem. To the word-association stem "friendship," Kahlo replied, "weapon" and "grandiosity/grandiose."[4] Her principal modes of psychological defense included intellectualization (the use of thinking to avoid feelings), somatization (using physical ailments to express emotional conflicts), sublimation (transforming emotional stressors of an amorous nature through painting), and denial (a refusal to grant the truth by using contradiction or disaffirmation).

Kahlo's affective state is obvious in her first response to the initial test, the Rorschach: "It has no color, it is gray with depths." The response indicates dysphoria—a chronic state of low-grade depression permeating many levels of psychological functioning—which is clearly transmitted throughout the testing, with recurrent themes of morbidity, hopelessness, incompleteness, self-derision, and mourning.

Rivera's request for a divorce in order to marry Félix removed Kahlo's major source of support. This was compounded by Rivera's assertion that he would continue his relationship with Hurtado. The extent of Kahlo's dependency is apparent in the intensity of her despondence in reaction to these relationships. She relied on others to shore up an unrealistically high self-appraisal and to avoid underlying feelings of inadequacy. From an interpersonal standpoint, this is the essence of pathological narcissism. Relying on external sources is inherently unreliable because others have their own needs and motivations. And an endless supply of gratification is needed, since the conflict cannot ever be resolved externally, regardless of repeated expressions of admiration by others. In order to resolve the conflict internally and obtain self-satisfaction, an individual needs a realistic sense of who he or she is. Kahlo had exceptional talent, intelligence, and beauty, but did not have a sense of any of these attributes. This is akin to having a handful of pearls but not being able to wear them,

since the string that might hold them together is unavailable. Hence, Rivera was the most important source of Kahlo's self-esteem.

While a common part of many women's early development is falling in love with "the unavailable man," this preoccupation is typically given up during adolescence. Because of her precarious sense of self-worth, Kahlo never adequately resolved this issue, playing it out with Rivera again and again, winning out over the other woman and feeling powerful, only to be devastated when Rivera's attentions inevitably wandered.

Rivera's philandering at this time had a devastating impact on Kahlo's mood. On card V of the Rorschach Test, popularly identified as a butterfly, Kahlo projected more: "A strange

butterfly, full of hair, flying downward very fast." This "strange butterfly, full of hair" appears to be a self-reference. "Flying downward" is consistent with her shift in mood: a descent into depression. Within six months of taking the Rorschach Test, Kahlo was hospitalized. Her psychic pain, as evident in the Rorschach Test, combined with her belief that Rivera's attention turned to her when she was ill, probably contributed to the hospitalization.

To a Thematic Apperception Test (TAT) card that relates to grief, picturing a woman standing in a doorway with her face in her hands, Kahlo stated: "This woman was in love, but she did not want to give herself. Finally she gave herself, and he went away, and she is by the door crying and crying. She will have to put herself to work because

It Seems So Difficult, c. 1949

the man who was going to support her has left her. I cannot do anything with this. I am very dumb, I cannot invent anything." Kahlo's self-deprecating addendum compounds her negative self-image and feelings of ineptitude with regard to functioning autonomously without Rivera.

To a TAT card picturing a woman watching another woman running on a beach, Kahlo stated:

They are poorly drawn. I do not know what the girl has in her hand. You do not know? The one who is above is waiting for the one who is running on the road. Both are in love with the same guy. She caught her. The one who is waiting is the one above for the one below. I do not know what she has in her hand; glove, purse, book, I cannot come up with anything.

Kahlo attempted to distance herself from the painful emotions inherent in two women in love with the same man—she and Félix or Hurtado, both in love with Rivera—with an intellectual comment about the poor quality of the drawing.

To a TAT card that pictures the silhouette of a man by an open window, Kahlo expressed disdain and cynicism as a response to romance: "It is the history of a young boy, romantic, who is seeing the moonlit night, very corny. Tired of working all day, he peeks out of the window, and he is going to sleep. He does not have a face that is happy with life. It is a scene completely vulgar and without transcendence."

On the Bleuler–Jung word-association test, to the stimulus "loneliness," Kahlo responded with two words: "me" and "fear." Thus, although Kahlo believed she could not "invent anything," her responses exposed the workings of her internal reality: the themes reveal her vulnerability through a devastating dependence on Rivera, and the fragility of her despondent and inadequate condition, since his support proved unreliable and her need for external assurance unsustainable.

In describing one of the four least-liked Szondi photographs, Kahlo explained: "This woman has suffered a lot. She is also not a normal person, and I see signs of cruelty. She is depressive, and has suffered poverty and tremendous sorrow for her illness or for her family. She has worked very hard, is quite masculine, completely bitter." In this statement, Kahlo projects an image of herself, forced to pay for the ineffectiveness of her defensive tactics.

Just how desperate and hopeless Kahlo felt is evident in the following TAT story, relating to a picture of a woman seated with her chin in hand, looking into space: "She does not eat well, and she is sad ... She is very overwhelmed by life. There is no solution, but she is not going to commit suicide. She is going to conform, but she believes herself to be very ugly. She has no male or female friends." The disavowal "she is not going to commit suicide" indicates that suicide was still on Kahlo's mind. A negative self-concept is also clear from the self-perception of ugliness.

Kahlo's TAT story for a card picturing a man leaning against a lamppost has an air of defeat: "A nebulous night. The individual leaning on a post is sad. Who knows what has happened to him to make him feel very lonely? He waits for somebody. It seems to me to be a country of the Orient. He seems to wear a Chinese suit, closed at the neck and long, long. I do not know why he has no movement." Note that Kahlo attempts denial—"I do not know"—after associating loneliness and sadness with immobility.

Kahlo's dependency on Rivera could only reinforce her sense of personal impairment. The importance of this struggle is revealed in her associations with the word "woman." "Mother" was her reply. To the word "mother," Kahlo replied twice with the same word: "son" and "son." The fetus Kahlo lost in 1932 was a male. Kahlo's inability to bear children confirmed her sense of inadequacy. Her self-concept incorporated marked feelings of incompleteness and loss, feelings that heightened her concerns about her ability to function independently. Desperation and feelings of ineptitude with regard to autonomous functioning resonate throughout her testing. The same themes, recurring in different tests and taken more than a year apart, indicate long-standing maladaptive behavior patterns and long-standing distress. People with such maladaptive behaviors are hypersensitive and will personalize comments or experiences. They easily feel insulted when no insult was intended, then blame others for their distress, often not realizing their own contribution to the problem.

Insults to Kahlo's self-esteem occurring in relationships were addressed with strategies to avoid and deny their emotional impact. On the Bleuler–Jung Test, to the word "forgive," Kahlo responded twice, "forget" and "forget." She forced herself not to consider another alternative, attempting consciously not to think about feeling wronged,

and thereby denying the emotional impact. Her repetition of "forget" indicates how hard she struggled with this issue.

The TAT story that Kahlo gave to a picture of a man turning away from a woman who is pulling on his arm sheds light on her view of men and sexual relations, and how she dealt with self-esteem injuries in relationships:

> *He is in love with a girl, and, since he cannot marry her, he went to a bad house [brothel]. He makes himself sick from making love with a woman of the street. Here, I see he is sickened with a biological need to make love. I cannot ... What am I saying? They make me laugh. I cannot do anything dramatic. Is the man a boxer? He is a good boy but dumb as a stone, filled with religious prejudice. His mommy and everything come to him when it is time.*

A man who "cannot marry" the woman with whom he is in love appears to be a reference to Rivera's inability to "marry" Kahlo in the traditional sense of monogamy. Once again, Kahlo is not making things up or being "dramatic," as this is the nature of her relationship with Rivera. Is she saying the man is unable to control his sexual impulse? What does she mean by making himself sick? She appears to be referring to venereal disease. There is a childlike dependency expressed in her sentiment that "mommy" will come when it is time. Kahlo's comment here that "He is a good boy but dumb as a stone," provides humor to help transcend the tragedy, but the humor has haughty and derogatory overtones.

Cruelty and sexuality are linked in Kahlo's description of one of the four Szondi photographs she liked least: "She has the face of a syphilitic woman, but she also has a religious obsession. She is cruel but not an idiot." To the word "pain," she responded "thorn" and "love." To the word "passion," she replied "violence." To the word "abuse," Kahlo replied twice with the same word: "trust" and "trust." Kahlo associated "sin" with "itch" and "habit." She linked sexuality, guilt, and shame.

Kahlo's TAT story in response to a picture of an older woman opening the door to a room was: "A lady becomes frightened about what is happening in her own home. She sees her daughter with a boyfriend. Very disgusted and sad at what she sees in the room. She was arriving peacefully, and she ran into something that irritated her. Of the future, I can say nothing. One can see he cannot stand her own dumb face." Worries

about the future and a negative self-concept are linked to relations between a man and a woman. The fright and helplessness in one's own home appear to be a self-reference. "Her own dumb face" reveals Kahlo's surprise at how transparent she is.

Kahlo's perception of sexual relations included deception. In response to a TAT card featuring a portrait of a young woman with an old woman in the background, Kahlo stated: "She has the appearance of a nun, but she is a true traitor. She covers up the entanglements of the young one, who is not so young anymore ... They swindle the man selling sex." Kahlo reveals that a part of her concept of the female sex role is the selling of favors in order to cheat men. But in a previous story, this strategy was not reliable: "She will have to put herself to work because the man who was going to support her has left her."

A cynical element in Kahlo's view of sex is again evident in relation to the next TAT card, picturing a young man standing and a woman lying in bed behind him: "They are two lovers, one a student and one a woman who does not look so young. He is disappointed at having possessed her. He is almost regretful, ashamed. He has a sense of guilt all the way. It is the first sexual experience that he has had, and it will serve him not to be so stupid the next time." Kahlo herself was a teacher. Perhaps, at the age of forty-two, she felt herself to be less attractive than in her younger years. To the words "old age," she replied "big" and "sorrow." She gave the lover less of herself than she had promised or had led him to believe she was going to give him, but the young lover in the story is judged severely as well. Self-loathing and contempt for innocence are revealed in the harsh, hostile judgment of a virgin lover. Kahlo's description of an unpleasant Szondi picture was: "It is also absolutely idiotic or criminal. He could be a priest, which is really the same. He is mean like a smack. One can do nothing in life with a face like that."

Kahlo showed Olga Campos letters that she exchanged with a male lover, letters that she attempted to keep hidden from Rivera. In response to the stimulus word "secret," she stated "love" and "fear." The following TAT story suggests the underlying interpersonal dynamics of this comment: "They were surprised, taking out a hidden paper. They are husband and wife. He discovers a letter, and she has a horrible fear and is dominated by her husband. She will have no other remedy than to get a divorce."

To a Szondi photograph that tends to evoke pleasant responses, Kahlo stated: "It [the picture] is absolutely sentimental, sick in the head, sad, bitter, and a very bad character. Also, he is an eighteenth-century character, but very spoiled by the mother and failed in his attempts at marriage. Quite sexual, sadistic. He is into poetry or music."

Subterfuge, secrets, fear, and domination are the themes of marital relations in Kahlo's responses. The wife engages in hiding information because she fears domination, finally seeking refuge in divorce to cover up her shame. In Kahlo's reading, the wife assumes a role of faux submission, which she attempts to overcome by keeping secrets, thereby gaining the upper hand. Kahlo seems unconsciously to have resented Rivera for having a power over her that she actually gave him. She also resented herself for not having the wherewithal to assert herself, and she suffered from this with feelings of humiliation and submissiveness. Here, her sense of emotional limitation mirrors her sense of physical limitation, as she appears "crippled" and unable to exercise adult independence.

Rivera did not want children and Kahlo did. This conflict resulted in great sadness for her. She referred to such sorrow in the following TAT story about a picture of a man and a woman together: "They are father and mother. That is, they are husband and wife, and have had a great sorrow: the loss of a son. They are going to say goodbye, never to see each other again. And they have spent more than twenty-five years together. Something tremendous has happened to them. Their son has died. The man is attentive to the love of the woman, who, though apparently weak, animates him." To the word "marriage," Kahlo replied "sack" and "nuisance." To "madness," she replied "husband." Kahlo hesitated and amended the nature of the relationship between the man and the woman when she said they are not father and mother but "husband and wife." This describes herself and Rivera, who remained husband and wife but never parents. With "family," Kahlo associated "children" and "father." She could not shift from the role of wife to mother.

The story also offers insight into the dynamics of Kahlo's relationship with Rivera. The woman in the story is "apparently weak," yet she animates the man. There is self-defeat in appearing weak in order to enliven someone else. It implies a self-imposed suffering consistent with the sadomasochistic features in Kahlo's relationship with Rivera. To "intimacy," she replied "fear" and "taste."

The strategy of appearing weak in order to animate a man may have developed early in Kahlo's life. Her mother may have used a similar strategy. For example, on entering menopause she developed seizures similar to her husband's epileptic seizures. These pseudo-seizures appear to have been a psychologically driven symptom in reaction to a potentially powerful psychic trauma triggered by menopause. This dynamic was probably further amplified in Kahlo's mind by her image of her father. She learned that weakness brought attention. Guillermo was frail, and Frida's frailty would have drawn them together as something shared, something that set them apart. To a Szondi photograph that usually gets a pleasant response, Kahlo replied negatively: "He is also ill from the madhouse. He has the face of a madman. He is also a very sad character. He believes he is not understood. He seems quite sensitive. He has the eyes of intelligence. He is middle class. I could not say what he did with his life. He did anything except be a teacher."

Kahlo's response to a TAT card picturing a dinosaur-like creature and a man reveals subtleties in the nature of her relationship with her parents:

Landscape of the beginning of the world with a dragon that peeks through a hole and sees another antediluvian animal that is parading himself. Man already exists, because there is a bridge on which a man runs frightened. There is such loneliness. It is very difficult to force myself to imagine things. It is a constant struggle among animals to keep their homes and food. I do like it. The civilization of man is going to arrive and ruin all this.

Kahlo appears to be talking about an experience that affected her indelibly. Antediluvian is how children often see their parents. The long-necked monster peeking through a hole suggests that Kahlo had a strong interest in what occurred between her parents. A feasible hypothesis is that Kahlo either saw or fantasized about her parents' relationship, marked by loneliness and struggle. "Landscape of the beginning of the world" suggests Kahlo's view of the beginning of her life. A frightened man already exists—her father? Kahlo states: "There is such loneliness. It is very difficult to force myself to imagine things." Once again, she does not appear to be imagining things so much as speaking of her early internal experience, and perhaps an empathic attunement with her father.

The affect connected with the memory is unbearable: "It is a constant struggle among animals to keep their homes and food." The struggle suggests Kahlo's view of the dynamics of autonomy and intimacy in her family. Kahlo recalled during the interview with Campos what a constant struggle it was for her family to keep their home, reaching a point where her father had to mortgage it. Kahlo goes on to critique the picture: "I do like it." This may serve to protect her from the painful affect of the story by using the opposite feeling, or it may reveal pleasure in the hardships her family endured: Kahlo regrets the passing of the crisis that brought the family together, because it served to combat her loneliness. "The civilization of man is going to arrive and ruin all this": this seems to refer to facing the demands of the adult world. There is a sense of regret and loss associated with the end of the story, which appears to be linked to an arrest in growth and development.

Kahlo and her father shared yet another emotional experience: the loss of a woman close to them who could have been the most important person in their lives. Frida said that Guillermo was never loved by Matilde, who remained in love with her previous lover, "another German, named Luis Bauer." In a very similar sense, Frida also lost Matilde: she was conceived shortly after her infant brother's death, and Matilde, still grieving, was unable to breastfeed her after her birth. The importance of Frida's relationship with her mother is demonstrated on the Bleuler–Jung Test. To the word "love," Kahlo responded "mother" and "everything." To the word "ideal," her reply was "thorn" and "love." Her theme is lost idealism, with pleasure and pain equated in a manner consistent with sadomasochism. When Frida was two months old, Matilde became pregnant again, and, absorbed with the pregnancy, she was, once again, unable to care for Frida. After Cristina's birth, Matilde's attention was further diverted. In the months following her birth, Frida also lost her first wet-nurse to alcoholism.

The following TAT story captures the common bond of loss between Kahlo and her father, as well as the emotional reality of such trauma. This story was given to a scene of a gaunt man (as she described her father), standing among gravestones: "This one is crazy, very sick in the head. He went into the cemetery desperate because his wife had died, or his mother. All his life is pure tragedy, tremendous, and without any hope. He is crazier than if you have breakfast. He is a mystical type, corny, sentimental;

the ugliest of all the cards. There is no other solution but for him to be tied up or for them to cure him." In response to a pleasant Szondi card, she stated: "The figure is of Irish or Scottish nationality, middle class, a professional watchman or employed by a jeweler, married with children, medium intelligence, and sentimental." Arriving in Mexico from Germany, Guillermo worked in a jewelry store, and, as a Sunday painter, he created sentimental paintings.

The next TAT card has no picture: the blank card. Kahlo's response was: "As if he went to paint a painting against the government of the U.S. Not against the people, with racial discrimination; with the Statue of Liberty on the first plane, and all the rottenness of the country in the background ..." In this angry scene, Kahlo appears to be referring to Rivera's experience in New York when his mural *Man at the Crossroads* (1933), for the Rockefeller Center, was destroyed. Intellectualization is evident in the specificity of her anger toward authority. Her story continues to bear the theme of loss that she expressed in the previous card. In response to the ultimate projective stimulus, a blank card, Kahlo follows her story of tragic emotional loss with a story of a painting. Paintings, in large part, became the means for Kahlo to address, shape, and confront her experience of loss.

The following TAT theme shows Kahlo's attachment to her mother: ambivalent and insecure. The card pictures a woman and a girl seated on a couch, the girl holding a doll. Kahlo told this story:

It is very strange. I do not get it. The woman is reading. It is a mother reading stories to her little daughter, and the girl is sad, as if she were in another world. She does not hear what the mother says. A cute little girl, and very sensitive, with a sense of motherhood because she has a doll. She cannot hear what the mother says. I cannot dramatize anything. The girl will never forget that her mother has read stories to her. Except that now, she is not paying attention.

Once her mother was available in a way, but no more. Kahlo is speaking of a deficit in integrating an internal representation of her mother. Without such integration, contradictory ideas and feelings coexist in a stark and extreme way, interfering with a cohesive sense of self; for example, Kahlo's contradiction in her story, where the girl will "never" forget, except now. The girl is withdrawn, isolated, and detached. Kahlo

emphasized that she could not dramatize the story. Perhaps she hoped that, if she were able to dramatize it, she could remove the isolated feeling. The mixed emotional tone of the mother–daughter relationship is distinct. Kahlo obviously did not dramatize or make up anything in this story. The theme reflects her relationship with her own mother as she probably experienced it internally.

Kahlo's negative response to a pleasant Szondi photograph seems to express identification with a mother figure: "It is like the eighteenth century. It looks like one of the anonymous paintings of Guadalajara. Good-looking but a bit fat. She is also from the middle class, received religious education in her home, and she is puritan but with an extremely strong sexual temperament that is repressed. A firm character, and with bad taste because of the dress that she wears."

Kahlo's identification with ballerinas in the Rorschach Test carries similar implications, in that her response conveys a damaged or incomplete sense of self: "Very pretty ballerinas without a head, and they are missing a leg. They are by Degas and carrying something strange, dancing." In the aftermath of the accident that Kahlo suffered while in the Preparatoria, someone referred to her as "the ballerina" as she lay wounded on the ground, her damaged body covered in gold dust that had burst from a paper sack that someone next to her was carrying. Ballerinas represent stereotypical, exaggerated, and idealized femininity, and, in this case, the concept refers to Kahlo's own sense of identity. Ballerinas are artists who display themselves in fancy costumes, and their lives revolve around the movement of their legs. Paradoxically, Kahlo also displayed herself in fancy costumes, and her life also revolved around the movement of her legs, but she dressed up to cover her deformity and to distract from it. Although the Rorschach card that provoked the ballerina response is achromatic, Kahlo saw the ballerinas as "pretty." She took great pains to look pretty herself. Even while in hospital, following surgery, she applied makeup before allowing herself to be seen, and she had her hair dyed while in bed.

Concomitant with the absence of an integrated internal representation of her mother, Kahlo's own sense of self was poorly integrated. Without a secure early attachment, Kahlo had great difficulty integrating various aspects of herself, such as her identification with her mother, her emotions, her intellect, and contradictory feelings.

On the Rorschach Test, this is reflected in her precepts of human-like figures: "A caricature without a head"; "In the background at the bottom there is an Aztec idol with its hands up high"; "Individuals are uncongenial with rag faces"; "On the borders of the images, there are a lot of figures, masks *et cetera*"; and "Figure of a woman, without arms, mannequin." These caricatures, idols, rags, masks, figures, and mannequins all represent the human form, but they are not real in the sense of being complete, live human beings. Other objects are flawed or damaged. For example, "Two ladies, with their hands up high, their heads are missing"; "A caricature without a head"; "Two individuals making a bow. They are missing a leg. They are in black tie with a woman's shoes"; "Two black men dancing without legs, their arms up high in movement"; "Two legs without feet"; "Pieces of earth, geography"; "Two images of pompadours, they are pieces of clay angels"; "The top part is strange elephants without tusks and with small trunks"; "Figure of a woman, without arms, mannequin."

Kahlo's personal sense of being flawed physically was tragically complemented by a feeling of emotional damage, which played a role in her identification with damaged subjects. From the age of about six, she dealt with the results of polio, which left her right leg shorter and thinner than her left. The bus accident injured her in a manner that led to long periods of confinement and chronic pain. Physical illness and multiple surgeries confirmed her sense that her body, as well as her self, was damaged. To the word "prayer," Kahlo responded "useless." To "hope," she replied "Amelia's sister." Kahlo did not even consider the feeling; rather, she indicated hope as the name of a person.

In a very clear sense, Kahlo was heroic. She demonstrated steadfast determination by repeatedly struggling to succeed in spite of dangers and disabilities. Her exceptional talent and capacity to paint while confined to bed and in pain are legendary. With the word "light," Kahlo associated "open" and "world," betraying a preoccupation with the freedom that she did not have. From our understanding, gained through testing, of her internal dynamics—filled with conflict, pain, a sense of incompleteness, and significant fears of functioning autonomously—her professional and social accomplishments seem all the more extraordinary. To the word "life," Kahlo responded "happiness" and "warmth"—a vision of her own existence free from chronic illness. Her image of

ballerinas missing a head and a leg while dancing likewise represents undaunted accomplishment. However, the implausibility of the actions that Kahlo projected on to these damaged ballerinas suggests in part how she addressed conflicts over her disabilities. Her responses indicate an irrational denial of what could and could not be done. Her impression of ballerinas dancing while missing legs, as well as heads, is an unreal possibility. Given her polio sequelae and the bus accident that further damaged her back, Kahlo did not have full use of her legs. And, given her childlike dependency, she also did not have full use of her adult capacities. She denied the obvious in order to protect herself from her painful reality.

Physical symptoms derived from emotional conflicts serve multiple psychological functions: to express emotional pain, to allow the conflict dominance over autonomous functioning, to garner emotional support from others, to address the narcissistic humiliation of a childlike dependency, to reflect an incomplete sense of self, to express hostility toward others and one's self, and so on. Psychological issues are difficult to address when they can be avoided through actual physical incapacity. In part, this is why chronic pain syndrome is so difficult to treat. Kahlo associated the word "physician" with "nuisance" and "panic."

Taking painkillers is another way that emotional pain can be addressed through somatic symptoms. The same medicine used to dull physical pain also suppresses—to a degree that is often considered sufficient—emotional pain. Of course, chronic use of this strategy will backfire sooner or later. The underlying cause of pain, when not resolved, remains unaltered and omnipresent. In between two anatomical interpretations on the Rorschach Test, Kahlo stated, "Transparent minerals, the same could be pills." Kahlo used painkillers, sedatives, and alcohol to ameliorate her physical and emotional pain, but, as the underlying causes went untreated, both her physical and psychological maladies not only went unresolved; they worsened.

Kahlo gave many anatomical readings on the Rorschach Test, which is consistent with her intense focus on her body. For example, "pelvis," "dorsal spine bones," "birds standing on top of the vertebrae," "an anatomical or biological drawing, a microscope field with strange animals," "blood," "part of a bone, is it the trachea?," "a forced female genital."

To an unpleasant Szondi picture, Kahlo responded: "An idiot or mentally retarded, she was born very ill, and, despite having a bad face, she is not a bad person; she is stupid. It is good that she died." To a TAT card picturing two individuals on a stairwell, she responded with a disdainful attitude toward deformity, and a passive, masochistic solution to suffering:

It looks like a mother who sees her deformed son, hunchbacked, very strange. But she also has some deformity in her hands. She has a lot of tenderness in the face and, because of her age, she has to be a mother and not a lover. Who knows what he is doing to the ears or neck. He almost resembles Quasimodo. She can only wait for that man to die. She loves him, but he is in her way a bit. Her only chance is to put up and suffer. She is of the working class.

Denial of emotion was a primary self-protective tactic for Kahlo when she felt overpowered by fears of incapacity. This, for example, was her first TAT story in response to a picture of a boy seated before a violin: "The boy is tired of studying the violin. He is desperate because he cannot play the violin and they make him study. He would like to have fun. It looks like he is being punished. Once he plays a little while, they will let him have fun. These things do not give me any emotion, that is the bad thing. They are stupidities ... such bad drawings." Kahlo's critical review of the drawing serves as an intellectual move away from acknowledging her deficiencies. The story melds punishment and coercion with a child's inability to learn. Kahlo's statement negates emotion, and is inconsistent with how the child feels in her story. She denies painful desperation due to fear by stating, "These things do not give me any emotion."

Desperation about independence pervades Kahlo's next TAT story, evoked by a farming scene with three central characters:

How barbaric. The girl is so desperate because of the pair of peasants working in the field. Since she knows what it is to work in the field, and how the woman is going to have a son, and she lives in the modern world, she feels sorrow for the pregnant woman. She is very sad, but she thinks she is going to find a solution to the world with her studies. There is no drama here. The girl is of another class, bourgeois. She has no business standing in the field. I do not see any more.

Intellectualization imbues the story as the girl finds a solution for world problems in her studies. Intellectualization aids autonomy: a solution will be found. Kahlo adds an intellectual critique to deny sorrow and sadness—"no drama here"—and distances herself further from the emotional aspects of the story with her comments on class elements.

In response to another TAT card, Kahlo stated:

Here, a frightening snow fell. The windows and the chimney are filled with snow. People are inside, warm and happy. The snow does not touch them. It is a family house, more or less poor. They could be sailors or people who live close to the port in Canada or around there. Whoever did the drawing did it so one would imagine where it is, but the drawing is so bad it failed. When the ice is over, they will have to go out and work.

To the TAT card of a woman on a bridge, Kahlo responded:

It is a very strange factory with poor architecture, like that of the devil. And on the border of the sea, a bridge and some ships are loading with I do not know what material. There is a foreman who makes everybody, all those that work, work like "blacks." He has them from the wing [he will not let up]. A girl is peeking at a bridge that cannot exist because it would fall. A sun, about the ugliest it could be. The printing is very bad. Whoever did it is very bad. I cannot give it a solution.

Despite valiant efforts, Kahlo cannot give "a solution" to the problems of the people in these stories. The next TAT card elicits a similar response: "What is this? It is a very poor girl who has to earn her keep, work to keep her whole family, her father, her mother, siblings ... She hopes somebody will take her out of the family." The wish to be rescued indicates that underlying desperation and inadequacy are unresolved. With early maternal loss, Kahlo had difficulty establishing not only a stable sense of self, but also the ability to tolerate the frustration of inevitable separations. This explains in part her repeated focus on damaged or incomplete objects. Her sense of incompleteness left her with serious concerns regarding autonomous functioning, dependency, and fears of abandonment.

In terms of Kahlo's thought process, her testing confirms cognitive slippage and discontinuity. This means that, at times, Kahlo was unable to finish a phrase coherently, and became either overly literal, idiosyncratic, or both. Kahlo merged feeling with

thinking during her conflicts. This approach is troublesome when it coincides with the serious difficulties in emotional modulation inherent in her chronic depression. One example of overly literal thinking is found in her associations on the Bleuler–Jung Test with the word "rose." She responded with "water" and "Covarrubias," the married name of Rosa Rolando, a friend who was the wife of the artist Miguel Covarrubias. Another example is found in her response to the word "town": "people" and "Chiconcuac," which is the name of a town in the state of Morelos. This style of thinking suggests that unconscious thought processes, childlike in their level of concreteness and lack of abstraction, slipped through.

At other times, the cognitive slippage involved inappropriate combinations of impressions that violate reality. For example, on the Rorschach Test this type of thinking is evident in such responses as "strange butterfly, full of hair"; "crickets with a rat's face and spider hands"; and "two pink bears." These examples illustrate disparate images inappropriately merged into a single object. Such creatures do not exist in reality, although in art they make for fascinating imagery, which could account for Kahlo's art being considered Surrealist.

Difficulties with rational, shared, linear logic also occurred when Kahlo posited implausible relationships between two objects on the Rorschach Test. For example, "Two men–lions, with an extended hand, and backs stuck together"; "two beings with wings, with animal faces, holding hands"; "two bull heads, sort of bulls, which are adorned with a headdress"; and "male genitals but with fire and thorns." Kahlo's very next response was, "The handle of a strange instrument, the instrument is gyrating." These last three responses suggest emotional conflict regarding male genitals. In the first, Kahlo undoes any aggression by adding a headdress. In the second, she is overcome with hostility. Kahlo makes things into what they are not, taking painful elements and adorning them to reduce their danger or starkness. Often, however, this tactic does not work, and she still becomes overwhelmed.

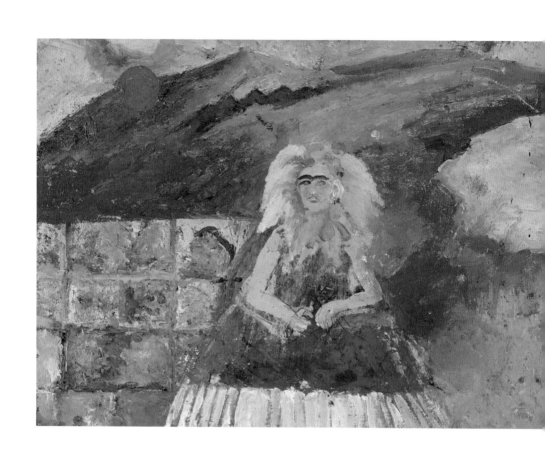

Summary

Frida Kahlo's personality testing is consistent with dysthymia (a chronic disquiet), with recurrent overlays of major depression and chronic pain syndrome, and with substance abuse in a narcissistic personality. Deficits in self-concept and self-integration underlie a central conflict between fears of autonomy and fears of abandonment. When the testing was initiated, the insult exacerbating Kahlo's chronic intrapsychic pain was Rivera's affair with María Félix, and the pain was augmented when he notified Kahlo that the relationship with Emma Hurtado was long-term. Fears of abandonment, established early because of childhood deprivation, combined with Diego's chronic philandering to sustain and intensify conflict over her autonomous functioning, which contributed to the deterioration of her health. Frida Kahlo battled these difficulties for decades, attempting to soothe or distract herself with "new" treatments, surgeries, and circumstantial or temporary love affairs that led nowhere. In time, as Kahlo became more despondent and depressed, her physical and psychological defenses became inadequate in the face of injuries to her self-esteem and relationship struggles. That is when she wrote in her diary "I am Disintegration."[5]

Frida Kahlo's struggle to sustain her sense of self, particularly in the area of self-regard, meant that she worked extra hard to be highly admired, thus sacrificing emotional depth and genuine empathy. To the word "sympathy," Kahlo replied "emptiness." Her internal battle between grandiosity and low self-regard, always intense, became debilitating. Eventually, she became more and more dependent on others to shore up her faltering self-esteem. Her struggle, which could be resolved only if addressed from within, never ended. Despite the richness of her internal world, as well as the world that surrounded her, Kahlo lived without working through her overwhelming dependency, doomed to perceive others as unreliable, and herself as incomplete.

Self-portrait in a landscape with the sun going down, 1954

NOTES

I thank Carmen Michael, Ph.D., for her valuable contribution to an early draft of this paper.

1. John E. Exner, Jr., *The Rorschach: A Comprehensive System* (New York: John Wiley & Sons, 1986).
2. Henry A. Murray, *Thematic Apperception Test Manual* (Cambridge, Mass.: Harvard University Press, 1943), p. 1.
3. Susan Deri, *Introduction to the Szondi Test: Theory and Practice* (New York: Grune & Stratton, 1949), pp. 1–25.
4. Kahlo's responses have been translated by Salomon Grimberg from Olga Campos's original notes, held in his own archive.
5. Kahlo wrote these words in an undated entry on page 41 of her diary, above a crumbling self-portrait showing one of her legs separated from her body as she falls off a column. Opposite her is the Egyptian horned god Khnum, or Khnemu, who, according to legend, "fashioned man upon a potter's wheel." In the judgment of the dead, one of the prayers went as follows: "… and the god Khnemu bestowed health upon his limbs." E.A. Wallis Budge, *Egyptian Religion: Ideas of the Afterlife in Ancient Egypt* (New York: Gramercy Books, 1959), pp. 125 and 168 respectively.

LIST OF ILLUSTRATIONS

PAGE 65
Amor (Love), from *Emotions*
1949
Conté crayon on paper
12 × 9 in. (30.5 × 22.8 cm)
Private collection
Photo: Christie's New York

PAGE 66
Inquietud (Disquiet), from *Emotions*
1949
Conté crayon on paper
12 × 9 in. (30.5 × 22.8 cm)
Private collection
Photo: Christie's New York

PAGE 70
Triple Self-Portrait—as a toddler,
adolescent, woman
1931
Pencil on paper
9 × 8¼ in. (23 × 21 cm)
Private collection, USA
Photo courtesy the collector

PAGE 72
Frida Kahlo working on *Self-Portrait*
on the Borderline, 1932
Unknown photographer
Photo courtesy Sam Williams

PAGE 73
Self-Portrait (Here I am sending you
my portrait so you will remember me)
c. 1920
Pencil on paper
5½ × 3½ in. (13.9 × 8.9 cm)
Private collection
Photo: Salomon Grimberg

PAGE 74, TOP
The First Drawing of My Life
1927
Pencil on paper
16¾ × 12¼ in. (42.5 × 31 cm)
Destroyed
Photo: Karen and David Crommie

PAGE 74, BOTTOM
Greek Mask
1929
Media and dimensions unknown
Private collection
Photo courtesy Yolanda Gerson

PAGE 75
Portrait of Rosita
1928
Oil on canvas
40 × 15¾ in. (101.6 × 40 cm)
Private collection
Photo: Sotheby's New York

PAGE 76
Portrait of Lupe Marín
1929
Oil on canvas
Dimensions unknown
Destroyed
Photo courtesy Ella Wolfe

PAGE 77
[Portrait of Salomon] Hale's Sister
1930
Oil on canvas
Dimensions and location unknown
Photo: Hayden Herrera

PAGE 78
Portrait of Salvadora and Herminia
1929
Oil on canvas
27⅜ × 21 in. (69.5 × 53.3 cm)
Private collection, USA
Photo courtesy Mary-Anne Martin/
Fine Art, New York

PAGE 79
Girl
1929
Oil on canvas
22⅜ × 18⅜ in. (56.8 × 46.6 cm)
Private collection, USA
Photo courtesy the collector

PAGE 80
Portrait of Cristina Kahlo
1928
Oil on wood panel
39 × 32 in. (99 × 81.3 cm)
Private collection
Photo: Christie's New York

PAGE 81
Portrait of Alejandro Gómez Arias
1928
Oil on wood panel
24¼ × 16⅛ in. (61.6 × 40.9 cm)
Private collection, Mexico
Photo: Galería Arvil, S.A.

PAGE 82
The Airplane Crash
1934
Media, dimensions, and
location unknown (ex-collection
Edward G. Robinson)
Photo: Lola Álvarez Bravo

PAGE 83
The Wounded Table
1940
Oil on canvas
47¾ × 96½ in. (121.4 × 245.1 cm)
Location unknown
Photo: Florence Arquin, courtesy
Sam Williams

PAGE 84
House in Harmony
1947
Pencil on paper
13½ × 8⅝ in. (34.3 × 21.9 cm)
Private collection, USA
Photo courtesy the collector

PAGE 85, LEFT
Guillermo Kahlo, n.d.
Unknown photographer
Photo courtesy Hayden Herrera

PAGE 85, RIGHT
Matilde Calderón, n.d.
Unknown photographer
Photo courtesy Hayden Herrera

LIST OF ILLUSTRATIONS

ACKNOWLEDGMENTS

The idea for this book was suggested by Regina Nankin Elfenbein (1923–1990). Regina was friends with Olga Campos in Mexico before moving to Dallas, where she married and settled. Regina had often heard Olga speak of her friendship with Frida Kahlo and Diego Rivera and, in 1989, when an exhibition of Kahlo's paintings was held in Dallas at the Meadows Museum, she invited me to meet Olga. At that time, she also asked whether I would be interested in working with Olga to turn her notes into a book.

Meeting Olga was, for me, a unique experience. She lived a simple, almost monastic life, which belied an extraordinarily rich internal world, populated by memories, moments of knowing, and a wise sense about who she was and those she had met and befriended. She had been deeply attached to the Riveras, especially to Frida. She was a regular guest in their home, treated naturally and affectionately as a family member, and made privy to information that few were to learn. She seemed to have known all the main players, everybody who was anybody, and known them well.

I am deeply grateful to Regina for introducing me to Olga and for suggesting the idea for this book, which was quite an adventure to pull together and publish. Olga knew that the information she held was a treasure, and adamantly insisted that it be treated with utmost care. She wanted its published form to be a document for consultation as well as for reading.

Olga had gathered each portion of the interview with Kahlo with the same affection with which Kahlo had shared it with her. When the information was given to me, it was in the form of notes, which had to be edited, separated by subject, and integrated coherently into a narrative. A proper introduction to the material, as well as to Kahlo's life, was needed. Also vital were Olga's remembrance of Kahlo and an interpretation of the psychological tests gathered by Olga. In reading Olga's notes, it was very clear that Kahlo held nothing back, and that she would have allowed Olga to delve deeper. That

Olga did not do so was an expression of her respect for Kahlo's intimacy, knowing as she did that the material would be published and that what she was gathering was enough to suit the purpose.

I cannot be grateful enough to Regina and Olga for choosing me to carry out the project. Although neither lived to see it published, I hope that, wherever they may be, they are pleased with the product of our labor. Olga had wished to dedicate the book to Regina, but now that both are gone, it seems fitting to extend the dedication to include these two dear friends.

Several other people were helpful at various stages in this book's history. Elizabeth Mills read the first draft of the manuscript and offered significant suggestions. I thank German Bolland, David Chasey, Yolanda Gerson, and Spencer Throckmorton. I am deeply grateful to César Campos, Olga's brother, who provided me with invaluable help at significant times, and to Jim Harris, for his fine evaluation of the psychological testing (I cannot imagine anyone doing it better), for his endless patience, and for his invaluable friendship. Hayden Herrera has been an available, generous, and selfless friend since before my first publication on Frida Kahlo, more than twenty years ago.

I owe a deep debt of gratitude to Roxana Velásquez Martínez del Campo and Alejandra Cortés Guzmán, respectively Director and Exhibitions Coordinator at the Museo del Palacio de Bellas Artes, Mexico City, for countless generosities. For their very fine and beautiful work, I thank the designer, Merideth Londagin of 3+Co.; the copy-editor, Philippa Baker; and the staff at Merrell Publishers: Joan Brookbank, US Director; Nicola Bailey, Art Director; Michelle Draycott, Production Manager; and Claire Chandler, Managing Editor. And finally, but particularly, I thank Ismael Grimberg, my father, for his quiet availability.

—SALOMON GRIMBERG

CONTRIBUTORS

SALOMON GRIMBERG, MD, is a psychoanalytic art historian who has written extensively on Frida Kahlo. His publications include *Frida Kahlo: Das Gesamtwerk* (1988), *I Will Never Forget You ...: Frida Kahlo to Nickolas Muray* (2004), and *Frida Kahlo: The Still Lifes*, also published by Merrell in 2008. He practices child psychiatry in Dallas, Texas, and is Clinical Associate Professor of Psychiatry at the University of Texas Southwestern Medical School in Dallas.

HAYDEN HERRERA is a renowned art historian and biographer who has lectured widely. Her books include the acclaimed *Frida: A Biography of Frida Kahlo* (1983). She lives in New York City.

OLGA CAMPOS (1923–1997) earned her psychology degree from the Universidad Nacional Autónoma de México, Mexico City. Drawn to the creative process, she designed a psychological test to evaluate the capacity of creative individuals to sublimate. The notes she gathered on Frida Kahlo's personal history and responses to traditional psychological tests form the core of this book.

HENRIETTE BEGUN, a German obstetrician–gynecologist, was based in Mexico at the time she gathered material for Frida Kahlo's medical history, in 1946. She died in California.

JAMES BRIDGER HARRIS, PsyD, is Clinical Assistant Professor of Psychology at the University of Texas Southwestern Medical School in Dallas, and Clinical Coordinator of the Eating Disorder Program at the Presbyterian Hospital of Dallas. He is in private practice and specializes in psychological assessment.

INDEX

First published 2008 by Merrell Publishers Limited

Head office
81 Southwark Street
London SE1 0HX

New York office
740 Broadway, Suite 1202
New York, NY 10003

merrellpublishers.com

British Library Cataloguing-in-Publication Data:
Grimberg, Salomon
Frida Kahlo : song of herself
1. Kahlo, Frida – Interviews
I. Title
759.9'72

ISBN-13: 978-1-8589-4438-8
ISBN-10: 1-8589-4438-4

Produced by Merrell Publishers Limited
Designed by 3+Co.
Copy-edited by Philippa Baker
Proof-read by Barbara Roby
Indexed by Candace Hyatt

Printed and bound in Italy

JACKET, FRONT: *Self-Portrait (Miniature)*, 1938
Oil on tin; Oval, 4¾ × 2¾ in. (12 × 7 cm)
Private collection; Photo: David Chasey

JACKET, BACK: Frida Kahlo, 1948; see page 100